a dictionary of

expressionism

by

JOSEPH-ÉMILE MULLER

translated from the French by

JEAN STEWART

Eyre Methuen

Layout design by René Ben Sussan

FIRST PUBLISHED IN GREAT BRITAIN IN 1973
BY EYRE METHUEN LTD
11 NEW FETTER LANE, LONDON EC4P 4EE
COPYRIGHT © 1972 BY FERNAND HAZAN, PARIS
ALL RIGHTS RESERVED S.P.A.D.E.M AND A.D.A.G.P., PARIS

PRINTED IN FRANCE BY IMPRIMERIE MONNIER, PARIS

ISBN
0 413 39700 9

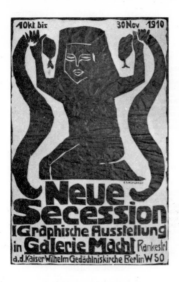

EXPRESSIONISM

Although the term Expressionism has been in current use for
more than half a century, it has by no means been strictly
defined. For one thing, the original meaning was completely
different from that which is usually attributed to it today.
In an article in the *Journal of the Warburg and Courtauld Institutes*
for 1966 the American art historian Donald E. Gordon points
out that the first group of painters ever to exhibit under the
title Expressionist were those whose work appeared at the
Neue Secession exhibition in Berlin in 1911, and that it comprised
only Frenchmen or painters living in Paris, in particular Braque,
Derain, Friesz, Manguin, Marquet, Picasso, Puy, Van Dongen
and Vlaminck. Since the works shown had been painted be-
tween 1907 and 1909, they must for the most part have belonged
somewhere between Fauvism and Cubism, presumably reveal-
ing the influence of Cézanne. The label Expressionist was once
again applied to some of these French painters by Herwarth

Walden, when in 1912 he displayed their work in his gallery *Der Sturm*. In the same year, it recurs in the catalogue of the great exhibition of contemporary art organized in Cologne by the *Sonderbund*, and this time it serves to describe Gauguin and Cézanne, Cross and Signac, Bonnard and Vuillard, Matisse, Picasso and Braque as well as Van Gogh, Munch and Vlaminck, Heckel, Kirchner, Schmidt-Rottluff, Kokoschka, etc. In short, the term now covered all those who had gone beyond Realism and Impressionism, in whatever direction.

Used thus broadly, the word naturally lost all significance. The point came, therefore, when it was considered more logical to describe as expressionist only those painters whose essential aim, in the distortion of visible reality, was to give outward expression in a striking manner to their feelings or ideas, and not those who used distortion primarily for pictorial ends. Secondly, there is a distinctive atmosphere about the work of modern expressionists: while they sometimes represent a generally somewhat hectic exaltation, in most cases they reflect a state of dissatisfaction, nostalgia, unease, which finds vent now in anxiety, anguish, neurotic torment, and now in revolt and protest, in violent denunciation. Their art tends usually to be sombre, highly strung, melancholy, passionate or poignant.

Granted this definition, it must however be admitted that the field of Expressionism has as yet no clear-cut boundaries. Such boundaries indeed would be hard to set, for the representatives of Expressionism have not evolved in seclusion; there have been contacts and sometimes exchanges between them and the protagonists of other contemporary tendencies, so that we can trace, in some cases, affinities with Fauvism, in others with Futurism and Cubism, or again with the Surrealists and the originators of abstract art. Conversely, we find some painters showing an occasional kinship with the Expressionists whereas normally they are poles apart from these. It is thus not surprising that the classification of certain artists is a tricky matter, and has given rise to much discussion; nor that the term Expressionist covers a considerable variety of manners, more particularly since we are here confronted not with a single movement but with isolated personalities or groups emerging at different moments and in different environments.

None the less one can divide the Expressionists into two main

classes: on the one hand the partisans of spontaneous expression, on the other those who do not exclude reflection and slow, painstaking work. The first, as a general rule, show little development and as soon as they feel less distraught or less rebellious their art often becomes sober and even traditional. Moreover, if we set aside Picasso and his followers, and the abstract painters, it must be said that on the whole the Expressionists are not primarily concerned with formal innovation. Like seismographs, they register the upheavals endured by man under the stress of contemporary reality, the dissatisfaction and the crises which it can arouse in him. Whereas some other modern artists reflect a relatively optimistic feeling about life, those with whom this book will deal are more affected by man's sufferings than by his triumphs, and remind us unremittingly that there are things in life that threaten us, that are capable of torturing us. As the world in which we live forces us frequently to face situations which disturb, depress or revolt us, it is natural that Expressionism should have developed and taken widely diverse forms, to the point of becoming one of the major tendencies of contemporary art.

Does this mean that it is a new phenomenon, characteristic of the present age and alien from all others? By no means: it is a tendency which for thousands of years has constantly appeared, has been eclipsed and then has revived. True, it does not always wear the same face nor reflect the same state of mind, but it invariably sacrifices the normal appearance of things to a concern for the powerful expression of some inner reality which has taken root in the mind or in the soul.

Prehistoric art includes some works which can be described as expressionist. The "Willendorf Venus" is a convincing example. In its exaggeration of the attributes of womanhood, we recognize the desire—specifically expressionist—to bring out something essential, without regard either for verisimilitude or for formal beauty or harmonious composition. We find expressionist works, moreover, in the art of the Sumerians and, abundantly, in that of the Middle Ages. Consider Byzantine art, with its stern-featured emperors, its sad, long-faced philosophers; the swirling figures of the Evangelists in the Ebban Missal, at Reims; the scenes on the bronze doors of Hildesheim Cathedral or the church of San Zeno in Verona; the

crucified Christs of the Romanesque period in Germany and in Spain, the *"Dévot Christ"* of Perpignan, the anguished Virgins and the bruised, broken, angular Christs of the Pietàs of the fifteenth and sixteenth centuries—all these works may well be considered as expressionist.

Many of them are the works of Germans. And Germany was the home of that old master who comes closest to modern Expressionism: Grünewald, the painter of that Crucifixion of the Isenheim altar-piece at Colmar where a greenish Christ, appallingly scarred by the marks of his scourging, stands out against a desolate sky invaded by oppressive shadows. Expressionist elements may also be discovered in the late works of Michelangelo, particularly his Last Judgement in the Sistine Chapel, and in those of Tintoretto; and they are even more notably evident in El Greco. This artist distorts human bodies to make them express his ideas, his spiritual fervour, elongating and emaciating them and giving them the shapes of flames writhing in the wind.

Rembrandt, too, is something of an expressionist towards the end of his career, in certain self-portraits and in the *Conspiracy of Julius Civilis*. Here a respect for naturalism and for physical beauty is replaced by a free rendering of psychological realities, immediately conveyed by his broad yet truthful treatment. The same terms can be applied to many of Goya's paintings, particularly those he made for his own house, the "Quinta del Sordo". A concern to render his visions by stressing their strange and disturbing character leads him to use predominantly dark greys and blacks, enlivened here and there by dabs of blue or red. The treatment, which appears sketchy, is actually extremely expressive, since it underlines the frenzied, delirious, demoniac element in his figures. Goya and Rembrandt have had many admirers among modern expressionists, who have also much appreciated Daumier, firstly because of his concern with bringing out the most striking characteristic of a figure or a scene, and furthermore because of his bitter social and moral criticism, his attitude of revolt and humanist protest.

Contemporary Expressionism has been further stimulated by various forms of exotic, primitive or popular art which have found a place in the "imaginary museum" of the twen-

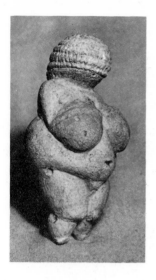

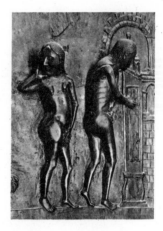

THE EXPULSION FROM PARADISE. 1015.
DETAIL OF BRONZE DOOR
IN HILDESHEIM CATHEDRAL

tieth century: Oceanian masks and statues, the carvings of
Black Africa, of pre-Columbian America, and so forth.
Finally, it was directly heralded by certain artists working in
the last century. I have mentioned that in Germany, on one
occasion, Cézanne was included among the Expressionists.
Even if one does not consider that he belongs there, it must be
admitted that he was one of the artists who made the emergence
of Expressionism possible. Basically, the movement was fur-
thered by all those painters who, breaking with the realism
of the Impressionists, opted for the use of invented and height-
ened colour: by Gauguin, Toulouse-Lautrec, Redon, the
Swiss painter Hodler, even by Seurat and the Neo-Im-
pressionists. However, if we wish to speak of its authentic and

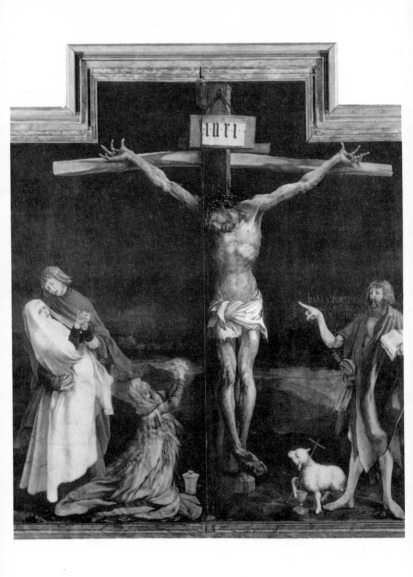

GRÜNEWALD. CRUCIFIXION. ISENHEIM ALTAR, 1512–1515.
UNTERLINDEN MUSEUM, COLMAR

REMBRANDT.
PORTRAIT OF THE ARTIST (DETAIL).
ABOUT 1665.
WALLRAF–RICHARTZ
MUSEUM, COLOGNE

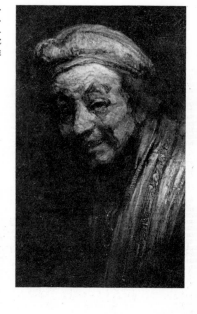

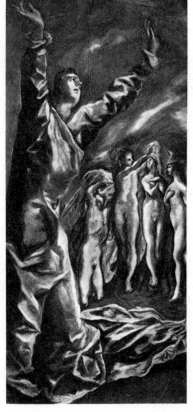

EL GRECO.
THE BREAKING OF
THE FIFTH SEAL.
ABOUT 1610.
MUSEO ZULOAGA,
ZUMAYA

immediate predecessors, we must cite only Van Gogh, Ensor and Munch. From the fact that the first was a Dutchman, the second a Belgian and the third a Norwegian, it has been deduced that Expressionism is alien to the French temperament. What cannot be disputed is that the Germanic countries have provided a more favourable soil for its growth. None the less, there have been painters in France who have, either consistently or sporadically, represented Expressionism, from the earliest years of this century, even before the development of the movement in Germany: Vlaminck was painting expressionist works as early as 1900, and Rouault by 1903. A more or less strongly marked tendency towards Expressionism was shown by other Parisian painters who, however, were of foreign origin: Van Dongen came from Holland, Kupka from Bohemia, Chagall from Russia, while Picasso was a Spaniard. Moreover these painters never belonged to a group (except for Vlaminck and Van Dongen, who were Fauves); there is not and there never will be an Expressionist movement in France.

The situation is different in Germany. Two groups were formed there before 1914 which, in varying degrees, represented and propagated Expressionism. The first, *Die Brücke*, was founded in 1905 in Dresden by four architectural students: Kirchner, Bleyl, Heckel and Schmidt-Rottluff, who were presently joined by Nolde, Pechstein and Otto Müller, to mention only the more important names. The second group was formed in Munich in 1911, and under the name *Der Blaue Reiter* it included notably Kandinsky, Marc, Macke, Campendonk and Klee. While in general its members were not as basically expressionist as the promoters of *Die Brücke*, it is nevertheless to one of them, Kandinsky, that we owe the invention of Abstract Expressionism. Besides these groups there were independents: Rohlfs and Meidner in Germany, Gerstl, Kokoschka and Schiele in Austria, and all contributed to make the tendency we are studying the most fertile trend which these countries had known for a very long time.

The *Brücke* group was dissolved in 1913 and the members of the *Blaue Reiter* were separated by the 1914 war. This, however, did not mean the end of Expressionism. Rather, the war—by multiplying dramatic situations, by provoking psychological

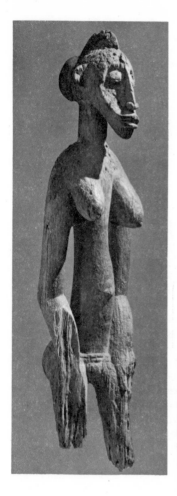

SENUFO ART.
FEMALE STATUE. WOOD.
RIETBERG MUSEUM, ZÜRICH

AZTEC ART. TLAZOLTEOTL, GODDESS
OF EARTH AND OF BIRTH.
FLECKED GRANITE.
ROBERT WOODS BLISS COLLECTION,
WASHINGTON, U.S.A.

tensions which, when exteriorized, inevitably brought forth an art imbued with anxiety and torment—exacerbated the expressionist tendencies of painters like Kirchner and Kokoschka. It accentuated or provoked them in other artists, such as the Germans Beckmann, Dix and Grosz, and the Flemings Permeke, Van den Berghe and Gustave de Smet. Nevertheless, the paintings which directly reflect the bloody reality of the period are exceptions: these artists incline rather to render states of mind than to depict historic events. In general their works reflect the war not through the evocation of scenes of battle but through an intensification of melancholy, bewilderment or revolt.

Moreover, we must avoid trying to explain everything by the war. Just as a first wave of Expressionism had made itself felt before 1914, in peace time, so did that second wave that spread over Europe after 1918 include a number of protagonists whose tendencies were determined by their own nature or the special conditions of their life. In any case, whereas in Germany Expressionism often appears as a product of great cities, which represent for it a disturbing, depressing, monstrous reality, in Flanders its originality is due to its close connection with the Flemish countryside. It also wears a rustic character in the work of the Swiss Auberjonois, the Dutchmen Sluyters, Gestel, Wiegman, Charley Toorop, Kruyder and Chabot. Between the two world wars, it assumed other aspects: with Kutter in Luxemburg, Boekl in Austria, Solana in Spain, Rosai, Scipione and particularly Sironi in Italy. During the same period it flourished in Mexico, notably in the work of Orozco, Siqueiros and Tamayo. Its adherents also became more numerous in Paris. But here neither Le Fauconnier, Gromaire, Goerg, La Patellière or Fautrier show the mastery of Rouault or the earthy toughness of the Flemish group. Among the newcomers in France it was, all in all, an immigrant, Soutine, who produced the most moving Expressionist paintings. Certain other immigrants (Modigliani, Pascin, etc.) also illustrate what has been called "Jewish pathos", but their art is less heart-rending than that of Soutine, their expressionism less sharply asserted.

In 1937 Picasso turned to account the achievements of Cubism to express with the utmost incisiveness his feelings

about the civil war in Spain. His example contributed to the emergence of a figurative Expressionism which was newer than that practised in the early years of this century; it had already made a transitory appearance in the work of Estève (1936), Le Moal and Chastel, and it is to be found later in that of several other painters, notably Pignon. Furthermore, a third wave of Expressionism accompanied or followed the war of 1939-1945. But once again it may frequently happen that an artist's evolution is determined less by outward events than by some private drama, some psychological disturbance of a purely personal nature. At all events, the paintings produced at this period can only partially be related to those of the previous years. The reason is that in addition to the influence of Picasso, figurative expressionism was now subject to that of Surrealism and even to that of abstract art, so that it became less realistic and less directly intelligible. Furthermore, abstract expressionism itself spread more widely than heretofore.

Another distinctive feature of the new situation was that national characteristics tended to disappear, and the single Expressionist group founded after the war (1948) was definitely international, as is indicated by the name it chose: COBRA, made up from CO (penhagen), BRU(ssels), A(msterdam). Its members included the Belgian Alechinsky, the Danes Jorn and Pedersen, the Dutchmen Appel, Corneille and Constant. While the art of this group lies on the border-line between the figurative and the abstract, in that of the French painters Gruber and Lorjou, the Swiss Gubler, the Belgian Landuyt and the Luxembourgeois Stoffel we recognize an Expressionism somewhat akin to that of the pre-1940 period. Certain other representatives of the trend show more formal inventiveness or more radical distortion. This is the case, in France, with Pignon, Rebeyrolle, Gillet, Maryan, Wols; in England with Bacon and Sutherland; in Germany with Antes; in Spain with Saura; in Holland with Lucebert; in the United States with de Kooning.

As for abstract expressionism, its adepts were legion in the 1950s; they merge, to some extent, with those of action painting. In Paris they include Hartung, Bram van Velde and, to a certain point, Wols and Schneider, but none of these artists is of French origin. It is therefore not surprising that a

great many abstract expressionists are to be found outside France: in Germany (Sonderborg, K. O. Gotz, Platscheck, Schumacher, Nay), in Belgium (Mortier, Burssens), in Holland (Lataster), in Italy (Vedova), and in the United States (Pollock, Kline); and the list might be prolonged. Of course these painters are not all expressionists to the same degree, and each has a distinctive manner; while some have recourse to spontaneous draughtsmanship, others make use of bright colours or an uneasy chiaroscuro. Their paintings, taken together with those of the figurative artists, prove that Expressionism is still a potent and widely diversified tendency.

DICTIONARY

ALECHINSKY.
THE DAUB.
1950.
LITHOGRAPH.
PRIVATE
COLLECTION

ALECHINSKY Pierre (b. 1927 in Brussels). Son of a Russian émigré of Jewish origin, he entered the École Nationale Supérieure d'Architecture et des Arts Décoratifs of Brussels in 1944 to study book illustration and typography. In 1949 he joined the COBRA group. Two years later, he settled in Paris. After working at engraving with S. W. Hayter in Studio 17, he studied painting in the Chinese manner from the Chinese artist Walasse Ting, and in the following year he went to Japan, where he made a film about Japanese calligraphy. That this should have attracted him is not surprising: already in the early 1950s spontaneous draughtsmanship had played an important role in his art. His manner at that time was generally non-figurative, whereas later he favoured a vaguely figurative style whose indirectness is almost furtive. Thus when he suggests human faces or the heads or eyes of animals, these are introduced stealthily, as it were, amidst a tangle of flowing serpentine lines and zones of fluid colour which, though somewhat acid, do not lack delicacy. Like the other adherents of the COBRA group, Alechinsky regards man as a creature both demoniacal and pitiful, to be viewed with irritation or amusement, but never displaying the slightest trace of dignity. Alechinsky's vision seems inspired by a sardonic humour rather than by deep-seated anguish, and this is not the only link between him

APPEL.
CRY OF FREEDOM. 1948.
STEDELIJK MUSEUM,
AMSTERDAM

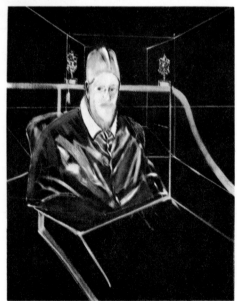

BACON.
STUDY FOR
A PORTRAIT
(AFTER INNOCENT X
BY VELAZQUEZ).
PRIVATE COLLECTION

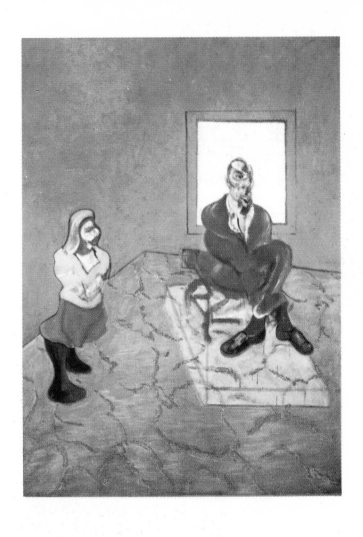

BACON. MAN AND CHILD. 1963.
PRIVATE COLLECTION

and Ensor, although in style (if not in colour) he differs widely from the Ostend master.

APPEL Karel (b. 1921 in Amsterdam). From 1940 to 1943 he studied at the Art Academy of his native city. In 1948 he was one of the founders of the Experimental Group of the Netherlands, which also included the painters Constant and Corneille and whose mouthpiece was the magazine *Reflex*. In 1950 he moved to Paris, where he spent the rest of his life. Already at that period his paintings are distinguished by a brilliance of colour and an awkwardness of draughtsmanship which remind one of children's paintings, although these seldom show the aggressive spitefulness of Appel's human and animal figures. This aggressiveness becomes more marked during the ensuing years; the handling grows more impetuous and more brutal, the rudimentary forms are replaced by the non-formal. Piling on to his canvases the most glaring reds and yellows, the densest blues and blacks, Appel intermingles them with vehement gestures, so as to load his paintings not only with broad, thick streaks of colour but with scratches, splashes, streams of paint, a tangle of brush strokes savagely intersecting and merging in a viscous magma. The subjects of his works (faces, nudes, animals) become embedded in this too, and often we can barely make out here a monstrous face or nude figure, elsewhere a bestial, threatening grimace. Phobias, obsessions and repressed desires, as well as wild anger, are revealed in Appel's art, where execution is entirely determined by instinct. In other words, we find here a kind of expressionist painting which corresponds to the Surrealist programme and where the means used resemble those of Action painting.

BACON Francis (b. 1909 in Dublin). Although born in Ireland, Bacon is an Englishman and has lived chiefly in London since 1925. A self-taught artist, he began painting in 1929, but in 1940 he destroyed almost everything he had produced up till then. His real career began in 1944. While he clearly appreciated certain of Picasso's distortions, he was also influenced by photographs, memories of cinema, X-ray pictures and illustrations from medical textbooks. His essential subject is the

human figure, and he offers us "portraits", nude or clothed bodies which in general have been not merely distorted but battered; the faces seem to have been disfigured by kicks or blows, they express bewilderment, terror, sullen hatred, rage, or stealthy vindictiveness. The limply curving bodies remind one of partially deflated rubber dolls. Usually set alone in rooms of whose emptiness one is painfully aware, these figures are sometimes seated in a cage formed by a few metal tubes, or else they are lying on the ground or on a flat bed like an operating-table, in the ridiculous yet tragic attitude of creatures which have fallen on their backs and cannot get up. When the model is Pope Innocent X as represented by Velazquez, he is seated on a more or less pontifical throne, his features blurred, his expression gloomy and peevish or else furiously uttering soundless cries like those one makes in a nightmare. And yet the ugliness of his figures and the painful aspect of some of his subjects do not preclude fascinating painterly effects. If his colouring, with its great flat patches of pink and lilac, violet, orange and acid green, has a strange and sometimes agressive character, it is very far from being commonplace, and despite the broad handling there are many delicate nuances in his painting, particularly in the battered faces.

BECKMANN Max (Leipzig, 1884 - New York, 1950). After studying at the Weimar Academy of Art and visiting Paris in 1903, Beckmann settled in Berlin in 1904. Most of the works he painted during the following years connect him with what is known as German Impressionism; in other words, he was a follower of Corinth. The 1914 war saw him mobilised into the army medical corps, where the unremitting sight of suffering and death had such an overwhelming effect upon him that he had to be invalided out of the army. And when he began to paint again his work recalls not Impressionism but Munch.

An acute unease pervades *Night* (1918). Seven figures are together in a tiny room: three brigands, who terrorize or torture their four victims with assiduous brutality. Although the schematic character of the forms and faces, and their diminished size, give them all the look of puppets, one is painfully aware of the cruelty and distress being so dramatically

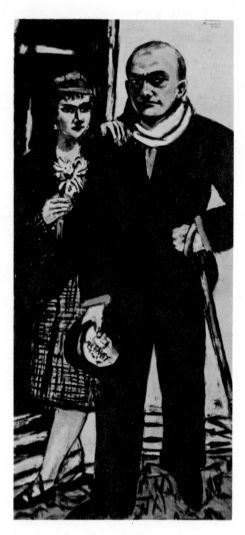

BECKMANN.
PORTRAIT OF THE ARTIST AND HIS WIFE. 1941.
STEDELIJK MUSEUM, AMSTERDAM

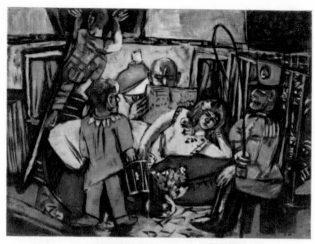

BECKMANN. THE CARAVAN. 1940

VAN DEN BERGHE.
FLOWERS ON THE TOWN.
1928. MUSÉE D'ART
MODERNE, BRUSSELS

25

displayed. Even when Beckmann shows us men and women preparing for a *Masked Ball* (1922), we sense around them an atmosphere of depressing ennui, indeed of haunting dread. At this stage, he seldom shows two human beings together without suggesting their mutual irritation and an inevitable, imminent clash. There is something equally disturbing about the landscapes he painted about 1920 in Frankfurt, where he was to live until 1933. Although the objects in these are defined by an emphatic outline, they do not give us the impression of belonging to the tangible world about us. Their very conspicuousness enhances their unreality: it is obsessional. Moreover, as almost all his straight lines are oblique, his buildings seem to stand upright only by a miracle and to be about to crash at any moment. And though the façades are intact, or at any rate have no visible cracks, this underlines even further the spectral character of these impossible architectural inventions.

Towards 1923 Beckmann's style begins to lose its constricted and mannered character. The brush strokes are still emphatic, but their purpose is to lend firmness to the structure rather than to reveal the instability of the whole. The colour had been clear and pale, here and there somewhat sugary; now it becomes harsher and more resonant. Curiously enough, while Beckmann now frees his figures from their puppet-like stiffness, he is still apt to show them in carnival costume or evening dress, and this cannot always be explained by their being at the theatre or in a bar. The ostentation with which his male figures wear their dinner jackets, or his women their evening frocks, contrasts with the insignificant expression of their faces, but emphasizes how much social life compels man to disguise his true nature. And yet there is less pessimism in these paintings than in those that preceded them, or those that were to follow after 1932.

It was in that year that Beckmann painted his triptych, *Departure*: on the central panel a legendary king is taking ship with his family to go into exile; on the side panels we see men and women bound, gagged and mutilated. The connection with the history of the period is clear: this work prefigures the fate in store for many men when Hitler took power in Germany. Beckmann was himself to undergo the ordeal of persecution: in 1933 he lost his teaching post at the Frankfurt

Academy of Art, and thenceforward he felt so ill at ease in his own country that he left it four years later. Until 1947 he lived in the Netherlands, and then went to settle in the United States. However, it cannot be claimed that his *Departure* lends itself to easy interpretation in every detail, and this is also true of his other triptychs. Whether they are called *The Temptation of St Anthony* (1936), *Perseus* (1941), *The Actors* (1941 - 1942) or *Carnival* (1943), they show a tendency towards hermetic symbolism, and Beckmann clearly sets greater store by this than by strictly painterly qualities. In these compositions, indeed, the colour is harsh and raw, the draughtsmanship schematic and rough. However, the portraits painted at the same period are expressive and yet free from that "literary" element which Beckmann introduces into his triptychs. Meanwhile, moreover, he was painting some remarkable landscapes, some of them spacious, others depicting relatively confined spaces in which objects are piled up and pressed together so as to preclude any glimpse into the distance. These works are notable, on the one hand, for their deliberate simplification, on the other for their rejection of anything immediately seductive and the persistence of that somewhat gloomy atmosphere characteristic of Beckmann.

BERGHE Frits van den (Ghent, 1883 - Ghent, 1939). He studied at the Ghent Academy and then in 1904 went to live at Laethem-Saint-Martin. During the nine years he spent there he painted in the Impressionist manner. The 1914 war drove him to take refuge in Holland and there, in association with Gustave de Smet, he developed in the direction of Expressionism. Many of the paintings he produced from 1916 onwards, with their sombre colours, their heavy, simplified forms, convey a sense not merely of disquiet but of anguish. *The Exiles* (1919-1920) look like victims of torture: figures in tight, funereal black clothes, with heavy hands hanging loose, brownish faces whose features seem blotted out by fear, with pale or dark blotches for eyes—terrifying eyes.

It would be untrue to say that after Van den Berghe's return to Belgium in 1922 this sense of anguish is completely absent from his work. Nevertheless between 1922 and 1925, when he was living at Afsne, he painted a series of works that reveal

MACKE. GIRLS UNDER THE TREES. 1914.
PRIVATE COLLECTION, AUSTRIA.

KANDINSKY. THE CHURCH AT MURNAU. 1910.
STEDELIJK VAN ABBE MUSEUM, EINDHOVEN

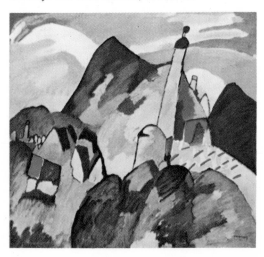

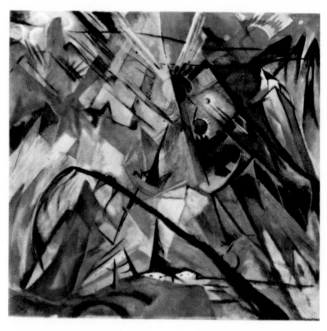

MARC. TYROL. 1913–1914. BAYERISCHE STAATSGEMÄLDESAMMLUNGEN, MUNICH

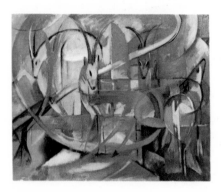

FRANZ MARC.
GAZELLE.
PRIVATE COLLECTION

a calmer spirit. Some of these are landscapes, or scenes observed around him: fishermen on the banks of the Lys, Sunday afternoon strollers. If, as is only natural, his palette becomes lighter in such pictures, sombre hues are not entirely absent. Even the most serene of landscapes cannot make Van den Berghe oblivious of his private feelings, his conception of life. In particular, he cannot see a human being without passing judgement on him, laying bare uneasy longings, unsatisfied desires, harassing obsessions. The female nude recurs constantly in his art, displaying her ample bosom and the robust curves of her hips, whetting and forever frustrating desire. Sometimes he depicts her headless, thus reducing her manifestly to the level of animal sexuality.

Stylistically, Van den Berghe's forms are as vigorously constructed as those of Permeke; indeed they are even more sculptural, and his colour is more varied. His paintings have a harsh sonority surpassing that of Gustave de Smet, and while his volumes are as strictly geometrical as the latter's, there is something more hot-blooded and occasionally turbulent about his work.

Towards the end of 1925 Van den Berghe left his home in the country to settle at Ghent, where he spent the rest of his life. His manner did not change right away in this urban setting, but he tended increasingly to give free rein to his caustic imagination and to emphasize the non-realistic character of his art. In 1928 his style itself altered: his lines now become sinuous and meandering, his forms less compact and less clearly articulated; his texture, which had formerly suggested the hardness of wood, assumes a spongy or gelatinous aspect. As for his colour, while it sometimes remains muted, it is also liable to assume a misleading prettiness, which just as much as the darker tints warns us that with a very few exceptions van den Berghe will henceforward offer us only that which is strange, abnormal, distressing and nightmarish. Grimacing monsters can be discerned even among flowers (*Flowers on the Town*, 1928) while in general human beings display only distorted bodies, outrageously flabby or obese, frog faces stamped with vicious or bestial impulses, terror or madness. These monstrous images, the product of a soul in torment, recur relentlessly in his work throughout the years. Undoubtedly the development of the

Surrealist movement contributed to their emergence, but the Surrealists did not so much influence Van den Berghe as encourage him to rid himself of his repressions in this way. True, the pictures he painted during the last ten years of his life must not make us forget the purely expressionist works of the preceding period. Yet if we consider certain contemporary artists, Dubuffet for instance, or the COBRA group, we must acknowledge Van den Berghe as a precursor, if an unrecognized one.

BLAUE REITER (Der). The group which the public first encountered at Munich between 1911 and 1914 under the name of *Der Blaue Reiter* (The Blue Rider), and which included such artists as Kandinsky, Marc, Macke, Klee and Campendonk, was unquestionably more influential in the history of contemporary art than *Die Brücke*, but its importance is not so great in the field of Expressionism. Although many features of this tendency are to be found in Kandinsky, particularly in the abstracts he painted from 1910 onwards, the protagonists of the *Blaue Reiter* were on the whole as much, or more, concerned with their artistic language as with the revelation of their feelings. Marc, Macke and Klee took their line from Delaunay, who obviously did not encourage them towards Expressionism. Inevitably, then, Klee finds no place in this book, where the other two are mentioned only for the sake of a few of their works. Usually the animals which Franz Marc (1880-1916) painted with such affection live in a Paradise garden. But in his *Destiny of Animals* (1913) the roe-deer wear attitudes of terror and bewilderment, and the slanting rays that assail them from every side are crossed like swords. Similar rays break into *Tyrol* (1913-1914), like a vehement clash of divergent forces, of hostile powers, giving the impression that everything is about to be overwhelmed by some cataclysm. In the work of August Macke (1887-1914) dramatic situations are even less frequent than in that of his friend. However, in 1911 he painted a *Storm* where the harsh reality of the natural phenomenon is represented both by the uneasy character of the colour and by the twisted flame-like lines surrounding the trees and the rocks. In his *Goodbye* (1914) the subdued tones and above all the sombre vertical lines compel attention; each of his figures

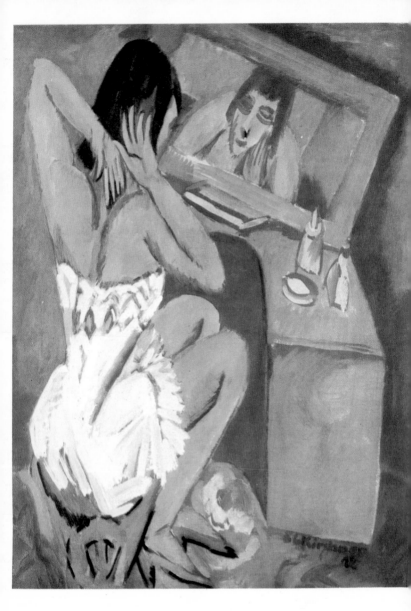

KIRCHNER. LADY WITH A MIRROR. 1912. PRIVATE COLLECTION, DÜSSELDORF

32

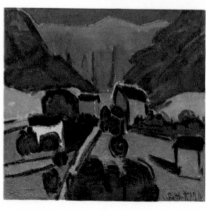

SCHMIDT–ROTTULFF.
NORVEGIAN LANDSCAPE.
1911.
PRIVATE COLLECTION

seems sad and anxious, as though surrounded by a void. Macke was impelled to paint this picture by the threat of that war in which Marc and he were to meet their death, and which the *Blaue Reiter* itself was not to survive.

BRÜCKE (Die). "The Bridge" was the name chosen by the first association of twentieth century artists in Germany whose trend was definitely expressionistic. Founded in Dresden in 1905 by four architectural students, Kirchner, Bleyl, Heckel and Schmidt-Rottluff, it was to include other painters, in particular Nolde, Pechstein and Otto Müller. But Nolde withdrew in 1907 and Bleyl ceased all activity in 1909, so that Kirchner, Heckel and Schmidt-Rottluff have remained the principal representatives of the group. To begin with, indeed, their association was fairly close. They met regularly, both for discussion and for work in common; and they were subject to the same influences, those of Van Gogh, Gauguin, the Neo-Impressionists and Munch, as well as that of African and Oceanian sculpture. Since all these painters, except Munch, also influenced the Fauves, we naturally find affinities between the latter and the members of *Die Brücke*, particularly as both groups expressed themselves by means of brilliant colour. Furthermore, the artists in Dresden were not unaware of what was happening in France, and during a visit to Paris Pechstein met Van Dongen, who shortly afterwards, in September 1908, was included in the third exhibition of painting organized by *Die Brücke*. Paintings by Marquet, Vlaminck and Derain were also shown, and the whole thing included enough of their works to give a clear conception of their art. Obviously Vlaminck and Van Dongen were the most closely akin to the German painters, but cannot be confused with them on that account.

As the German artists declared in their 1906 programme: "We wish to win freedom to act and to live by taking up our stand against all that is old and well-established". Despite their opposition to their predecessors in Germany there was one point in which they remained in their country's tradition: what is commonly called the content of a work, its theme, its emotional effect, its psychological significance preoccupied them to a far greater extent than what is commonly known as its form. The

same attitude had been that of their nineteenth-century pre-
decessors, whether their paintings were literary and symbolist
as in the case of Feuerbach and Böcklin, or akin to Impression-
ism, as with Liebermann, Uhde, Slevogt or Corinth.

The painters of *Die Brücke* are notable not only for the
violence of their colour but also for the harshness and angular
rigidity of their forms. They were in fact greatly interested in
the practice of wood engraving and, following the example of
medieval German woodcuts, they went in for a primitive sort
of draughtsmanship with strong tonal contrasts.

The first phase of the history of *Die Brücke* ends towards the
close of 1911, when the lack of success of their exhibitions in
Dresden impelled Kirchner, Heckel and Schmidt-Rottluff to
settle in Berlin, where Otto Müller and Pechstein had already
been living since 1908. Here they made contact with Herwarth
Walden, the founder of the magazine and art gallery *Der Sturm*
(The Storm), through which he strove to popularize the inno-
vators that appealed to him, both German and foreign. His
activities undoubtedly encouraged the new tendency which
the three painters from Dresden had adopted under the direct
or indirect influence of Cubism, at that time the most advanced
movement in the realm of figurative art. True, neither Kirchner
nor Heckel nor Schmidt-Rottluff sought merely to follow in
the Cubists' footsteps. They made no attempt to break down
volumes, but simply gave them a more geometrical character
and tightened up the construction of their compositions. Often
they subdued their palettes without, however, resorting to the
asceticism of Braque or Picasso. Moreover they never consented
to consider the human figure solely as pretext for an analysis
of forms; it retained for them its moral, spiritual and emotional
reality, from which they could not dissociate themselves.

A different sort of phenomenon took place in Berlin: the
group lost its cohesion, and by 1913 it had dissolved, "officially"
because Kirchner had written a Chronicle of *Die Brücke* of
which his friends disapproved, but equally, or indeed mainly,
because each of them had become aware of his own idio-
syncrasies and intended, more than ever before, to assert them.

CHABOT Hendrick (Sprang, Netherlands, 1894 - Rotterdam,
1949). He attended evening classes at the Academy of Rotter-

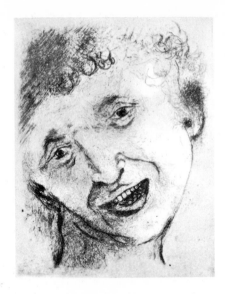

CHAGALL.
SMILING SELF—PORTRAIT.
1924–1925.

CHAGALL. THE STUDIO. 1910. THE ARTIST'S COLLECTION

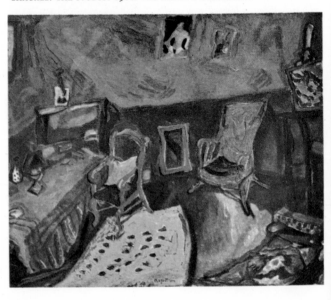

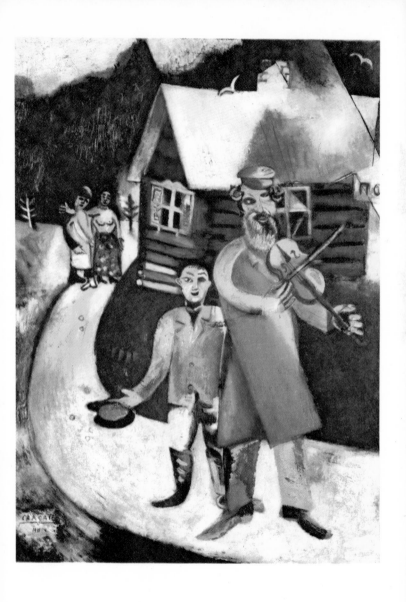

CHAGALL. THE VIOLINIST. 1910–1914.
MR AND MRS R. STURGIS INGERSOLL COLLECTION, PHILADELPHIA

dam, where he had been living since 1906. About 1926 he began
to be influenced by Flemish Expressionism, and in 1930 he went
to Brussels to visit an exhibition of Permeke's work. He took
to painting peasants and domestic animals, like the Flemish
artist, but his figures lack the monumentality and the generous
vitality of Permeke's. As for his colour, it is austere and harsh,
made up of earthy yellows, browns and greens. During the
second world war Chabot depicted prisoners, fugitives, resist-
ance fighters, and then his art becomes charged with an
emotional intensity which is neither sentimental nor theatrical,
but a bleak acceptance of the ineluctable: the natural conse-
quence of a barbarous situation, faced with grim resolution.
A similar atmosphere pervades his landscapes, particularly that
which depicts the burning of Rotterdam in 1940 after its
bombardment by Hitler's aircraft (in which the artist's studio
was destroyed together with a major part of his work). But
even in those pictures which make no direct reference to the
war, summer scenes are painted in sulphurous yellows and
convey a sense of tragic menace.

CHAGALL Marc (b. 1887 at Vitebsk). One might be tempted
to say that a great part of Chagall's work is expressionist, since
this artist interprets psychological realities by an extremely
free use of distortion. But in that case we should have to apply
the same remark to the Surrealists, which obviously nobody
would seek to do. Logic therefore requires us to define the
position of this painter in greater detail. He showed a leaning
towards Expressionism in 1909, in St Petersburg, and even more
in 1910 when he came to Paris, where the example of Van Gogh
encouraged him to make up a brighter palette than he had
used hitherto. Thus in his *Studio* (1910) the colours suggest
nervous tension and the objects seem so insecure that this
picture appears to herald the art of Soutine. In 1911 Chagall
was led by Cubism to discipline his handling and to give his
form a more geometrical quality. If certain of his works still
convey an atmosphere which may be described as expressionist,
it would be wrong to use that term about most of the pictures
he painted after this date. These often derive from the free play
of fantasy, a kindly fantasy on good terms with the world.
Nevertheless the ferocious madness of Nazi anti-Semitism and

the atrocities of the last world war were to tear him away from his fabulous universe, and between 1935 and 1945 a certain number of his paintings reflect the horrors of the time: martyrs, crucified figures (not always of Christ), mourners and fugitives, burning houses, in short real life dramas, are here set before our eyes.

DIX Otto (Untermhaus, near Gera, Thüringen, 1891 - Singen, Baden, 1969). In 1909 Dix entered the School of Decorative Arts at Dresden, where he studied until the 1914 war, when he became a soldier. With the advent of peace he resumed his studies at the Art Academies of Dresden (1919-1922) and Düsseldorf (1922-1925). Over the years, he had already produced a number of works which are by no means devoid of interest. Those inspired by the war, and various pictures painted in 1920, show that he was not unfamiliar with Cubism and Dadaism, but he eventually adopted a meticulously realistic manner which became known as *Neue Sachlichkeit* (New Objectivity) and which suggests a kinship with the German masters of the fifteenth and sixteenth centuries. He differs from these by the fact that his realism, instead of being respectful, is bitter, vindictive and accusing. With cruel coldness Dix lays stress on the ugliness of bodies and souls, on deformities, misfortunes and meanness, on situations that are grotesque, painful or disgusting. When he paints whores, they are even more repellent than those of Rouault. And when in 1920 he takes as his theme disabled servicemen, he depicts them as so horribly mutilated, and equipped with such frightful artificial limbs, that they no longer even arouse pity. Dix is merciless even in those paintings where he represents those for whom he feels sympathy, a workman for instance or his own parents. Driven by the Nazis as early as 1933 from the teaching post in Dresden Academy which he had held since 1925, he retired to Southern Germany and settled, in 1936, at Hemmenhofen near Lake Constance; there he painted landscapes which have nothing expressionist about them. Nevertheless in the works he produced after the last war (portraits, religious subjects) his very style is closer to modern Expressionism than it had ever been: realism is cast aside, the forms assume a primitive look, the draughtsmanship is broadened and the colour becomes

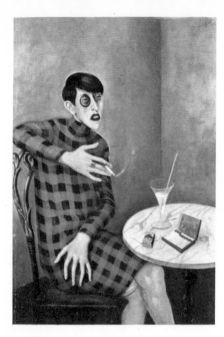

DIX.
PORTRAIT OF SYLVIA
VON HARDEN.
1926.
MUSÉE NATIONAL
D'ART MODERNE,
PARIS

VAN DONGEN. ANITA. 1905

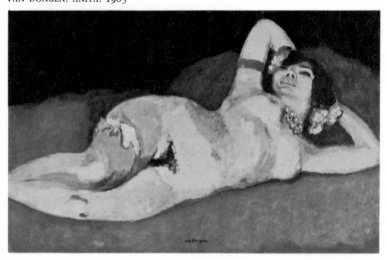

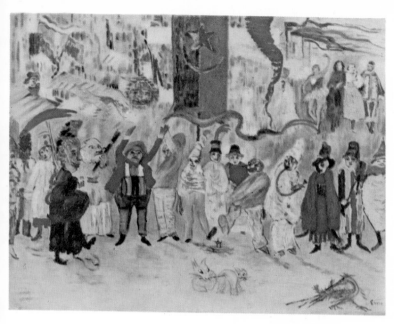

ENSOR. CARNIVAL. 1888. STEDELIJK MUSEUM, AMSTERDAM.

ENSOR. INTRIGUE. 1890. MUSÉE ROYAL DES BEAUX-ARTS, ANTWERP

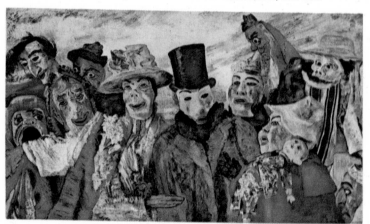

brighter and freer.

DONGEN Cornelis T. M. known as Kees van (Delfshaven near Rotterdam, 1877 - Monte Carlo, 1968). Van Dongen, who came to Paris in 1897, was one of the leaders of Fauvism, and many of his works are by no means expressionist in the strict sense of the word. His attitude to life, in fact, is neither one of unease nor of revolt; his art betrays no pessimism, no melancholy or dissatisfaction. The women he loves to paint are always sensuously seductive, and make-up enhances the natural charm of their faces. His clowns exist only for the amusement of the public and for the pleasure of the painter. Nevertheless we are reminded of Expressionism when we consider the emphatic and symbolic use of form and colour in paintings like the *Femme fatale* of 1905 or the *Hussar (Liverpool Light House)* of 1907 or thereabouts. We can understandt herefore the appeal of Van Dongen for the painters of the *Brücke* group, who included him in certain of their exhibitions even though the whole atmosphere of his work differs so widely from theirs. With Van Dongen we witness the expression of a powerful sensuality by means of brilliant colour (and that sensuality reappears in the society portraits he painted after 1918), whereas the strident chromaticism of the artists of the Dresden school reveals an anxious and sometimes aggressive neuroticism.

ENSOR James (Ostend, 1860 - Ostend, 1949). Ensor, who only left his native city to study at the Academy of Brussels between 1877 and 1880, began by using a subdued and somewhat sombre palette. Towards 1884 he discovered Impressionism, and thenceforward he used all the colours of the rainbow. His aim was however not simply to set down the effects of light which he observed; when he paints a still life he refines and enriches the colour of objects with a freedom that foretells the colouristic inventiveness of Bonnard. And when he depicts the sea, the beach or the sky of Ostend, his picture takes on the iridescence of sea-shells and fishes; human beings and objects become weightless, unreal, fantastic. In short, he makes us discover an imaginary world instead of reconstructing something actually seen.

But it is when he represents his fellow men that this artist

displays his individuality the most strikingly. He had begun, at first, by depicting them with respect and even with affection. But by 1883 he had come to consider them ironically, with an amused smile or with biting irony. He shows man as a mere skeleton decked out in grotesque and tawdry motley, or else wearing a mask which, instead of disguising the shameful inner truth, makes it manifest by stressing to the point of caricature the features that reveal it. Ensor delights in imagining comic, even farcical situations. Here, skeletons trying to keep warm gather round a stove; elsewhere, they fight over a hanged man or a herring; in another picture a fleshless skull emerging from a shroud is surrounded by masks expressing either foolish indifference or whining unhappiness, spite or bogus tragedy. The largest and most famous, if not the finest, of all the works of this group is the *Entry of Christ into Brussels*, a vast composition crowded with masked figures. Painted in 1888, at the very time when Van Gogh was working in Arles, this startling canvas is one of the first examples of modern Expressionism.

"I confined myself joyfully", Ensor has said, "in the solitary realm where the mask reigns in all its violence and brilliance. The mask decrees: freshness of tone, high-keyed expressiveness, sumptuous settings, broad unexpected gestures, disorderly movements, exquisite turbulence." This declaration is interesting because it proves that while he undoubtedly had the preoccupations of a moralist, Ensor (who in this connection reminds one of Van Gogh) never lost sight of the strictly painterly qualities of his pictures. In fact, his works hold our interest not only through the way they pillory arrogance, vanity, stupidity and feebleness, but also because they have delectable qualities as paintings. And though he speaks of "turbulence" and of "high-keyed expressiveness", it must not be assumed that his colour is merely strident. On the contrary, it is often of extreme delicacy. Subtle and unusual tints are as frequent in his work as garish ones.

Like several other expressionists, Ensor practised engraving, particularly etching and drypoint. These show that he was a masterly draughtsman as well as an appealing colourist. And when he depicts *Devils going to the Witches' Sabbath*, *The Battle of the Golden Spurs* or *Bathing at Ostend*, his humour, his fantasy, his comic and his fondness for jokes (stimulated by Bosch and

ENSOR. ENTRY OF CHRIST INTO BRUSSELS (DETAIL). 1888.
LOUIS FRANCK COLLECTION, LONDON

DE SMET.
THE POACHER. 1925.
KUNSTMUSEUM,
BASEL

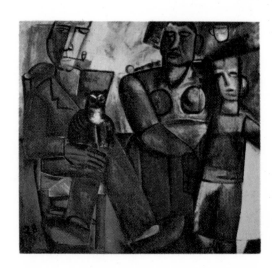

PERMEKE.
PEASANT
FAMILY WITH A CAT.
1928.
GUSTAVE
VAN GELUWE
COLLECTION,
BRUSSELS

Bruegel) are revealed even in the mocking, mischievous quality of his line.

Unfortunately Ensor was one of those artists whose creative power is soon exhausted. Though he lived until 1949, all the work that has earned him a place in the history of art was achieved before 1900. He went on painting long after that date, but with few exceptions his later works show signs of strain and the old freshness has dried up.

FLEMISH EXPRESSIONISM. Whereas after 1918 we find no Expressionist movement either in France of in Germany, there developed one in Belgium, more specifically in Flanders, which was as original as it was important. Here as elsewhere the ground had been prepared by all those who since the end of the nineteenth century had reacted against the luminism and hedonism of the Impressionists: by Ensor primarily, but also by artists such as Jakob Smits (1856 - 1928), and Eugène Laermans (1864 - 1940). Smits, who was born in Rotterdam and who settled in the Belgian Campine in 1889, painted some excellent portraits and also landscapes and rustic and religious scenes. A warm-hearted and occasionally sentimental painter, he used a sober palette and brooding chiaroscuro; his forms, except in his portraits, are rudimentary and clumsy. Laermans, whom total deafness made particularly sensitive to the lot of the unfortunate, also expressed his sympathy and compassion through sober colours and simplified forms. The first group of artists to settle at Laethem-Saint-Martin, a small village on the Lys, not far from Ghent—Minne, De Saedelaer, Van de Woestijne—were Symbolists rather than precursors of Expressionism. None the less, from the early years of this century, the work of Gustave van de Woestijne (1881 - 1947) shows peasants' faces painfully distorted and stresses their surly character. Furthermore, in the paintings on religious subjects which he produced after 1920, the face of his Christ is pervaded by tormenting anxiety, not to say neurotic anguish. A second group of painters settled at Laethem between 1904 and 1909, and it was these men—Permeke, Van den Berghe, Gustave de Smet and Servaes—who were the real founders of Flemish Expressionism. But, except for Servaes, they were only drawn to this tendency after they had left the

village, where they had dedicated themselves to luminism. Their evolution was instigated or hastened by the 1914 war, which drove all three from their homeland. While Permeke took refuge in England, De Smet and Van den Berghe fled to Holland. Influenced by the Frenchman Le Fauconnier, and the Dutchmen Sluyters, Piet and Mathieu Wiegman, but also by magazines and prints which told of the new artistic tendencies in Germany, the two painters adopted a new manner the better to express their feelings as exiles. When they returned to Belgium in 1922, each of them had achieved expressionist works which were more than merely promising. It was after regaining their native land, however, that they produced their most significant and substantial paintings. The same is true of Permeke.

The great period of Flemish Expressionism was between 1920 and 1930, when its influence spread beyond national frontiers. Thus whereas towards 1917 De Smet and Van den Berghe had been inspired by Dutch painters, it was Belgian artists now, Permeke in particular, who gave the lead to Dutchmen such as Gestel and Chabot. Among their compatriots, too, there were artists (Tytgat, Brusselmans, Floris Jespers, Ramah, Saverys, Malfait) who illustrated the same tendency with varying degrees of force. There was also Paul Maas (1890 - 1962), who from 1930 onwards and particularly after the second world war used a tachiste technique in an impetuous rendering of figures, nudes, landscapes, scenes of harbours and of beaches invaded by disorderly crowds. Right up to the present day, younger artists show that Expressionism still has its adherents in Belgium, both in the field of figurative art (Landuyt) and in that of abstraction (Burssens, Mortier).

GILLET Roger Edgar (b. 1924 in Paris). He studied in Paris at the École Boulle and at the École des Arts Décoratifs. For several years he painted abstracts which cannot be described as expressionist. Towards 1964 his art became more or less figurative, and his pictures are crowded with creatures with smudged or barely sketched-in faces, limp and swollen bodies, and legs as thin as those of frogs or spiders. Sometimes these shapeless monsters express the tragic decomposition of the mind through madness, sometimes—as is the case in his more

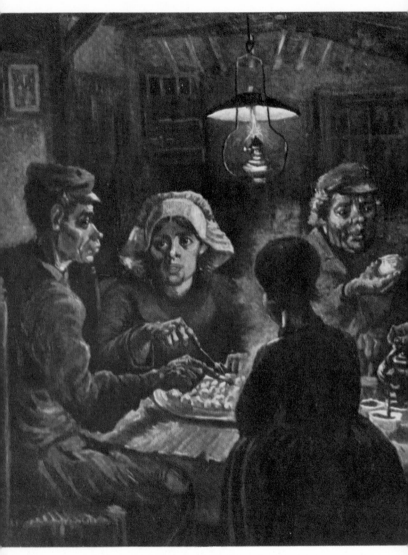

VAN GOGH. THE POTATO EATERS (DETAIL). 1885.
VAN GOGH MUSEUM, AMSTERDAM

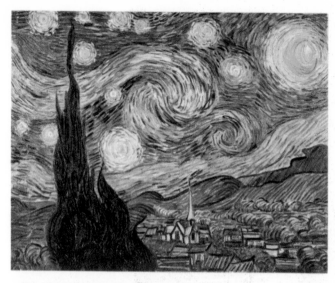

VAN GOGH. STARRY NIGHT. 1889. MUSEUM OF MODERN ART, NEW YORK

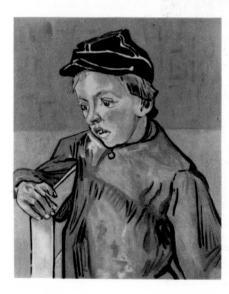

VAN GOGH.
THE SCHOOLBOY.
1888–1889.
MUSEU DE ARTE,
SAO PAULO

49

recent works—they are simply grotesques, for example suggesting would-be fashionable women with the absurdly bewildered faces of rats or toads. Yet while Gillet displays contempt for humanity, seeing it as hideous or grotesque, he does not despise painterly virtues: his colour may be sombre and earthy but it is not unappealing.

GOGH Vincent van (Groot-Zundert, Holland, 1853 - Auvers-sur-Oise, 1980). It would be untrue to say that Van Gogh became a painter against his will, but it is important to note that with his whole heart and soul he began by wanting to be something else. After being employed for seven years (1869-1876) by the picture dealers Goupil in The Hague, London and Paris, he felt urgently drawn to religion, he longed to relieve the sufferings of the poor and sought to become a minister like his father. His ignorance of Latin and Greek presented obstacles to this project which, for all his zeal, he was unable to overcome. He then decided to go as a missionary among the miners of the Borinage district in Belgium. Here again he failed; he had not the gift of eloquence and, which was probably a graver objection, he practised the teaching of the Gospel so zealously and with such dedication that his shocked superiors dismissed him from the mission. It was only then (about 1880) that he began drawing and painting, partly to prove that he was not an "idler", and partly to convey through art the feelings that he had been prevented from expressing as a missionary. For a few months he studied at the Brussels Academy of Art (1880-1881), then worked for two years at The Hague, with occasional lessons from his cousin, the painter Mauve.

His earliest works represent the simple folk he had seen in the Borinage, or in various parts of Holland (Etten, Drenthe, Nuenen): miners' and fishermen's wives, a weaver, a spinner, peasants. To paint them in all their harsh reality he made use of dark colour and a heavy yet impassioned handling. "If a painting of peasants has the smell of bacon and potatoes about it, that's perfect!" he declared. Thus his *Potato Eaters* are rough people, refractory to civilised life, and he portrays these characteristics with violence. The picture thus created in 1885 anticipates the expressionism of the Fleming Permeke and that of

the Dutchmen Wiegman and Chabot.

Early in 1886 Van Gogh went to Paris, where contact with the Impressionists and Neo-Impressionists led him to change his style completely. When we look at some of his Montmartre landscapes with their light touch, their airy, serene and almost elegant colouring, we might assume that he had also changed his nature. But his self-portraits contradict that impression, for they betray unease and nervous tension. It is thus not surprising that he reverted to expressionism when he left Paris in 1888 to settle at Arles. True, he retained the palette of his Impressionist period, but he broadened the patches of colour, heaping them up or spreading them out so as to enhance their brilliance, in order to express his thoughts and feelings with more intensity. In his *Night Café*, he sought to show "that the café was a place where one might ruin oneself, go mad, commit crimes". In *The Sower*, the sun, set like a huge disk behind the man's head, has something overpowering about it. One has the feeling that the sower would like to escape from it, but shade is non-existent; there is no possible refuge.

Van Gogh's expressionism became more marked when he was suffering from his attacks of madness, the first of which led him to cut off his ear (end of 1888). A heart-rending anxiety can be felt in the *Starry Night* which he painted in 1889, at the asylum of Saint-Rémy where he had been confined, at his own request, a few weeks previously. The sky seems to have been invaded by a hurricane come from the remotest depths of the universe, which makes the clouds writhe and the stars whirl. It cannot be denied that such a painting is the work of a sick man, but his sickness does not alone explain its style. Van Gogh had Gauguin in mind when he simplified his composition, emphasized its lines of force, rendered his forms synthetic and underlined the dominant characteristics of each of them.

Indeed, for all his intensely passionate and excitable nature and his final illness, Van Gogh retained his lucidity as an artist (except, of course, when he was in the throes of an attack). His last self-portrait shows us a face almost shattered by mental torment. Yet there is nothing strident about the colours, in which light blue predominates, and the swirling lines are firm.

In May 1890 Van Gogh left the asylum of Saint-Rémy and

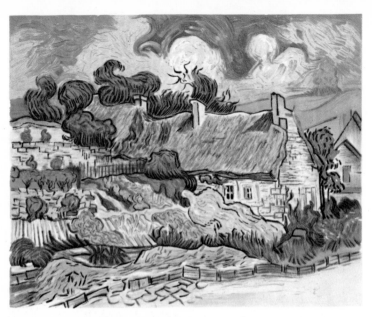

VAN GOGH. THATCHED COTTAGES AT CORDEVILLE. 1890.
MUSÉE DE L'IMPRESSIONNISME, PARIS

VAN GOGH. LANDSCAPE NEAR AUVERS. 1890.
PRIVATE COLLECTION, ZÜRICH

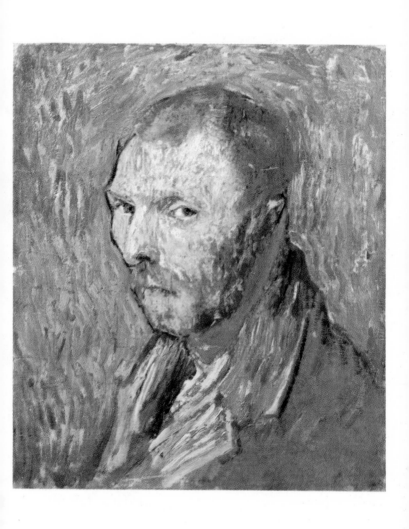

VAN GOGH. PORTRAIT OF THE ARTIST. 1889.
NASJONALGALLERIET, OSLO

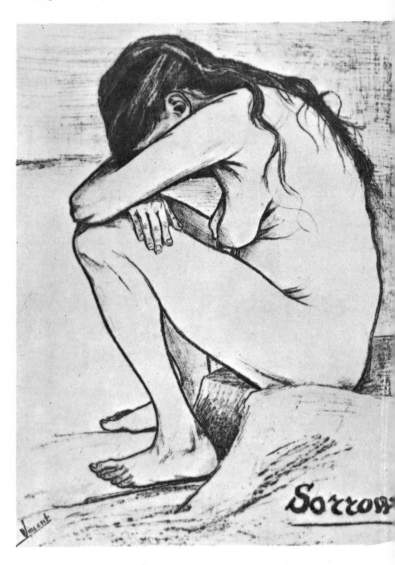

VAN GOGH. SORROW. LITHOGRAPH. 1882

went to live at Auvers-sur-Oise. If in some of the pictures he painted the handling is somewhat less assured, others, both portraits and landscapes, are masterpieces. Despite the mental anguish he endured (which eventually drove him to suicide), this deeply moving expressionist strove not only for force and intensity but also for beauty of expression. There is no lack of subtlety in his work, and his compositions always show a concern for order and balance.

GROMAIRE Marcel (Noyelles-sur-Sambre, 1892 – Paris, 1971). In 1912, after studying painting at various Parisian art schools, he worked at La Palette with Le Fauconnier, who was then a representative of Cubism: to this school Gromaire owes his concern with construction and his preference for geometrical forms. His nudes, furthermore, reflect a sensuality about which there is nothing morbid. None the less he has his place in this book because of the bitterness and pathos conveyed by certain of his pictures. Thus when, between 1921 and 1927, he paints peasants at their meal, beer-drinkers or skittle-players, a mower whetting his scythe or some soldiers of the 1914 war sitting in their trench, inert and massive, he portrays human beings as heavy, stubborn, harsh-featured, square-jawed, with broad vigorous hands and bodies that seem hacked out of old tough wood. Gromaire's colour is no less austere than his form. There are many shades of brown in it; his blues are greyish, the glow of his reds is subdued. Generally speaking, his art is the reverse of effusive; it is grave and disciplined, and his distortions are often dictated by the requirements of form.

GROSZ Georg (Berlin, 1893 – Berlin, 1959). He owed less to his studies at the Dresden Academy, the Berlin School of Decorative arts and the Académie Colarossi in Paris than to the caricatures in *Simplicissimus*, Japanese prints and the work of Daumier and Toulouse-Lautrec. The paintings and drawings he produced before 1920 reveal, moreover, an acquaintance with both Cubism and Futurism, and immediately after the first world war he was one of the moving spirits of the Dadaist group in Berlin. Although towards 1921 he turned to a more realistic style, his aim remained the same: to denounce the evils of a world which disgusted him. Exasperated by the injustice

GROMAIRE.
NUDE WITH LONG
BLONDE HAIR.
1957.
PRIVATE COLLECTION,
PARIS

GROSZ. DOWN WITH SUBVERSIVES, UP WITH UNIFORMS

and absurdity he saw around him, revolted by militarism, nationalism and hypocritical morals, Grosz stigmatized them ferociously. He depicts oafish soldiers dreaming only of revenge, or shooting down workers; crippled or blinded ex-soldiers reduced to begging for alms; unscrupulous and self-indulgent business men, arrogant bureaucrats, vulgar prostitutes; he brings them together in the streets of Berlin, catches them unawares in bars and brothels, and invariably seeks to stress their most revolting and ignoble aspects. His essential medium being his pitiless line, Grosz is more significant as a draughtsman than as a painter. The most aggressive and important period of his activity came to an end in 1932, when he left Germany for the United States, where he was to live until 1959, shortly before his death.

GRUBER Francis (Nancy, 1912 – Paris, 1948). Gruber was one of the very few painters of his generation to produce appealing works while remaining faithful to the tradition of realistic drawing, because his line has a highly individual quality, seeming to flay the form that it defines. His colour, in which cold and acid tones predominate, is equally individual, so that Gruber's painting, although its idiom is relatively un-inventive, has an accent, a vibrancy with cannot fail to touch us. Moreover, there is a visionary as well as a realist in Gruber; he admires Hieronymus Bosch and Grünewald, and his work sometimes assumes a surrealist quality. Thus in some of his paintings the figures are surrounded by startled birds or fantastic creatures, and the atmosphere is always charged with intense melancholy. Moreover, the shivering and emaciated bodies of certain figures, particularly his nude and semi-clothed women, enhance the sadness that their expressions convey.

GUBLER Max (b. 1898, Zurich-Aussersihl). Gubler's Expressionism developed with the intensification of the mental troubles that finally led him to the asylum. The works he produced in the Lipari islands (1923-1927) are distinguished by the gentle paleness of their colour, but his figures already wear a serious and somewhat morose look. From 1930 to 1937 he lived almost exclusively in Paris, and here again he painted figures that seem obsessed by nostalgia. It was after his return

to Switzerland that his art became predominantly charged with anxiety and tension, in spite of an increased use of clear, bright, rather cold colours. His wife, who appears repeatedly in his paintings, has a sullen look, and his self-portraits reflect a vulnerable yet obstinate nature. After 1950 these characteristics are accentuated, and there comes a point where objects lose all consistency. In the last paintings Gubler made before his confinement in the mental home (1957-1958), his wife has become a mere pallid spectre, while the lines and colours that make up his landscapes are primarily signals by which an unquiet mind asserts its struggle against the darkness. In 1954 he began a series of canvases inspired by *Thistles*. Since Gubler's self-portraits recall those of Van Gogh, and since he suffered a like fate, we are inevitably reminded in these works of the series of *Sunflowers* painted at Arles, which are Van Gogh's hymn to the sun and to life; here, on the contrary, we are confronted with the remorseless withering power of death.

HARTUNG Hans (b. 1904, Dresden). An admirer of Rembrandt and Goya, as also of certain contemporary masters such as Corinth, Slevogt and the German Expressionists, Hartung began to paint about 1921 while he was still at school in Dresden. If certain of his works have identifiable subjects, others are frankly abstract, but all of them may be described as expressionistic: the brushwork is vehement, with many jagged lines. Between 1924 and 1930 Hartung studied at the Academies of Leipzig, Dresden and Munich, but in 1926, after visiting an exhibition of modern art in Dresden, he developed a special enthusiasm for Picasso and Rouault, and between 1927 and 1930 he stayed in Paris on three occasions. He returned there in 1935 when, a fugitive from Nazism, he left Germany for good. He was soon to discover that abstract draughtsmanship which became his favourite mode of expression. Having joined the Foreign Legion in the second world war, he was so gravely wounded in 1944 that he had to have a leg amputated. He resumed his work in 1945, and from now onwards his palette which, except perhaps for a time round about 1922, had never been warm or glowing, becomes sober and austere. Moreover, he remains insistently a linear artist. His lines, drawn with nervous vehemence, cross and intertwine,

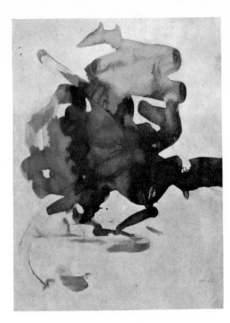

HARTUNG.
WATERCOLOUR. 1922.
PRIVATE
COLLECTION

HARTUNG. PASTEL. 1950–1953. PROPERTY OF THE ARTIST

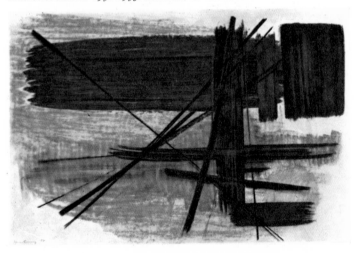

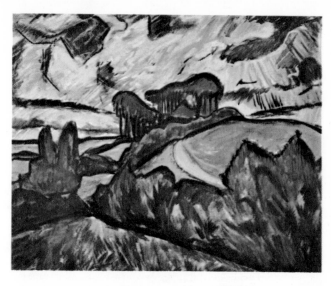

HECKEL.
LANDSCAPE IN HOLSTEIN.
STÄDELSCHES
KUNSTINSTITUT,
FRANKFURT–
AM–MAIN

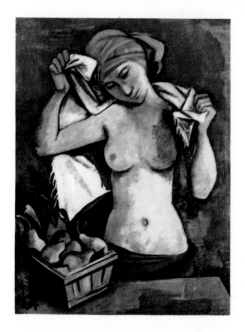

HOFER.
NUDE WITH BASKET
OF FRUIT. 1928.
WALLRAF–RICHARTZ
MUSEUM, COLOGNE.

reach out or break off, sweep one another along or clash. Conflicts between light and dark passages interact with the conflicts suggested by the drawing, and generally the darks prevail, the lights being relegated to the background, remote from the viewer like a sky seen by a prisoner through the bars of his cell. Hartung's style was to change to some extent in course of time, as his single strokes turned first into blotches or blade-like shapes with sharp edges, then into scratches swiftly scoring the canvas. On the other hand his art did not maintain its dramatic character, nor, consequently, its expressionistic intensity. None the less the works he achieved between 1945 and 1954 must undoubtedly be reckoned among the most original examples of abstract Expressionism.

HECKEL Erich (Döbeln, Saxony, 1883 - Radolfzell, Baden, 1970). Like the other founders of *Die Brücke*, Heckel worked at Dresden, round about 1906, in a style that shows the influence of the Impressionists and of Van Gogh. His portraits, nudes and landscapes are painted in pure colours in impetuous juxtaposition. He took the themes of his landscapes sometimes from the country round Moritzburg in Saxony, sometimes from Dangast in Oldenburg, where he stayed and painted near his friend Schmidt-Rottluff. His work is less ponderous than the latter's, more reserved than that of Kirchner. In his *Female figures in an Interior* (1909) there is a delicate tonality, and the composition has a decorative quality that denotes a concern with pure painting. By this time, moreover, his manner had lost its original impulsiveness and he tended to lay on his colour in flat tints surrounded by dark lines.

In Berlin, where he settled towards the end of 1911, the influence of Cubism and his contacts with Feininger, Marc and Macke led him to harden and geometricize his forms. At the same time, the changed appearance of his figures betrays a view of humanity even more pessimistic than that of Kirchner. Their faces are now pale and angular, their expressions grave or distraught, their eyes clouded by some obscure apprehension or tormented by anxiety, their gestures alternately rigid and tremulous; whereas formerly this painter had shown mankind in a calmer light, as less passionate but also as less insecure. Furthermore, his colours have become more subdued. Glowing

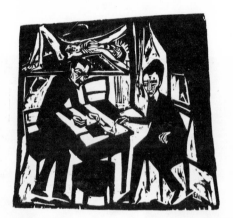

HECKEL.
TWO MEN
AT A TABLE. 1913.
WOOD ENGRAVING

reds give way to chilly yellows and faded blues. In *Two Men at a Table*, painted in 1912 and dedicated to Dostoyevsky, blacks and dirty ochres, yellowish greens and sombre reds combine with the stiff, jagged character of the drawing to convey the pathos of the figures and the exasperating constraint of the world in which they are confined. Heckel's figures retain this melancholy uneasiness until after the 1914-1918 war. The same spirit, in another form, is revealed in his landscapes; here it is shown in the way he treats light, making it clash dramatically with the shadows which it stabs and fragments. Long shafts of light rend his skies, and while one is naturally reminded of Marc and Feininger, one must recognize that with these two artists the rays of light are more regular and do not suggest the anguish implied here. When peace was restored, Heckel's distress abated and he turned towards a quieter, more conventional form of art, which lacks the interest of the works painted between 1906 and 1914.

HOFER Karl (Karlsruhe, 1878 – Berlin, 1955). Hofer, who studied in the closing years of the last century at the Academy of his native city, lived for a number of years in Rome and in Paris before settling in Berlin in 1913. He was in Paris again when the 1914 war broke out, and this led to his internment in a camp where he remained until 1917. His experiences

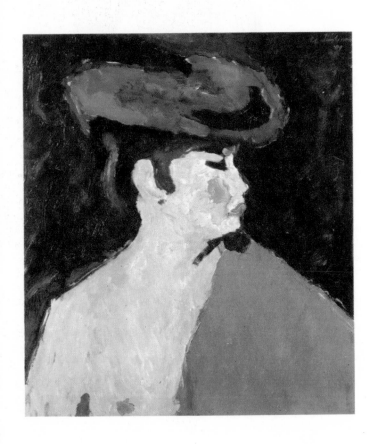

JAWLENSKY. THE RED SHAWL. 1909. PRIVATE COLLECTION, MUNICH

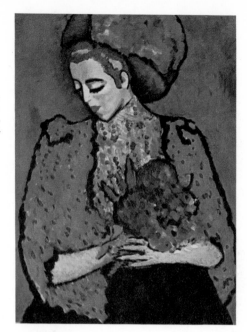

JAWLENSKY.
PEONIES. 1909.
VON DER HEYDT MUSEUM,
WUPPERTAL

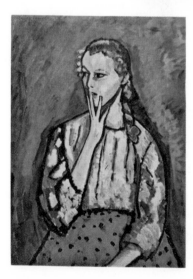

JAWLENSKY.
PORTRAIT OF A GIRL.
KUNSTMUSEUM.
DUSSELDORF

65

during this period doubtless account for the morose atmosphere that pervaded his art when he returned to Berlin in 1918. In any case, it was only after this point that he can be considered as an expressionist, since previously his art shows the successive influences of Böcklin, Hans von Marées and Cézanne. Moreover his painting always remained deliberate and free from violence; his forms are simplified but never uncouth; his colour avoids stridency; his brushwork is careful and agreeable. But the general effect is of a certain dryness and, particularly in his landscapes, a certain timidity. When Hofer depicts human beings, they are often masked figures; his couples, his young men and girls dwell in melancholy solitude, from which their need for affection and for love rarely rescues them. His women are sad, submissive creatures, whose male companions are care-ridden and abstracted; and if they seek affection from other women, they are stricken with remorse, and caresses bring them no happiness. There is little variety about Hofer's manner or his themes, and when his studio in Berlin was destroyed by an air raid in 1943, he painted some of the lost works over again.

JAWLENSKY Alexej (Torschok, near Tver, Russia, 1864 – Wiesbaden, 1941). Although he studied painting in the art schools of St Petersburg and Munich, where he went to live in 1896, the direction of his art was finally determined by Van Gogh, Cézanne and Matisse. He made contact with the latter in 1905, at the time of the sensational Fauve exhibition at the Salon d'Automne. Henceforward, therefore, he gave free rein to his love of pure colour, particularly in the works painted after 1906, where the dominant hues are laid on in broad stretches. His still lifes, landscapes and figures express intense poetic feeling; his glowing yellows and reds and dense blues are reinforced, here and there, by vibrant blacks. Jawlensky does not avoid harsh colour relations, but he is careful never to make them vulgar. While the expressionist character of his painting is due above all to the high tension he establishes between the various colours, his draughtsmanship also contributes to it. During the course of his career his line becomes increasingly emphatic; to begin with he surrounds his forms with a broad contour, then, by 1911, in the interests of greater

simplification, he reduces them to rough schemata. Moreover, while emphasizing the frontal character of his rounded or oval faces, he enlarges the eyes and makes the pupils bulge, so that the expression becomes grave and often somewhat hieratic. One is reminded of the Fayyum portraits, and of certain Byzantine heads, such as that of Theodora at Ravenna; one recalls, also, the paintings under glass produced in the village studios of Bavaria and Bohemia.

The 1914 war obliged Jawlensky to leave Germany, and he went to Switzerland, where he lived until 1921. Then he settled in Wiesbaden. In the meantime his form had become increasingly geometrical, and the many faces he painted from now on, all constructed according to the same formula, display so strict a regularity that they cannot be described as expressionistic. On the other hand, the term is once more applicable to the paintings produced between 1934 and 1937. A crippling arthritis then prevented the artist from drawing regular lines; any sort of painting became difficult for him, and his art lost its stiffness and precision; his lines became broader and less steady, his handling clumsier; eventually his colour was dulled and impoverished. At the same time a sense of tragedy, and occasionally an element of mysticism, creeps into the best of these *Meditations*, and it is not surprising that one of them bears the title *Good Friday*.

JORN Asger (Vejrum, Denmark, 1914 - Copenhagen, 1973). Asger Oluf Jorgensen, who since 1945 signed himself Asger Jorn, began painting in 1932. Four years later he went to Paris to work first under Léger, then with Le Corbusier. He was also influenced by Klee and Miro, among others. During the war he was back in Denmark. In 1948 he was one of the founders of the COBRA group, which reacted vehemently against the strictness and the calculations of geometrical abstraction. In 1951 ill-health obliged him to enter a sanatorium, where he remained for nearly a year and a half. In 1953 he settled in Switzerland, and after 1955 he lived alternately in Paris and at Albisola Marina near Genoa. The paintings he did in the 'fifties still show traces of the emphatic structure of his early work. But this has become dislocated: in these vaguely representational pictures, disturbing faces emerge uncertainly from the patches

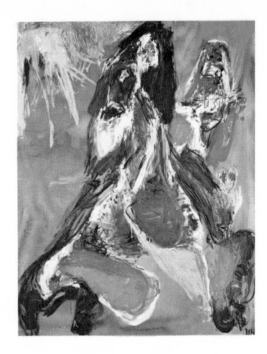

JORN.
THE SUN BORES ME.
1961.
PRIVATE COLLECTION.

KANDINSKY. FIRST ABSTRACT WATERCOLOUR. 1910

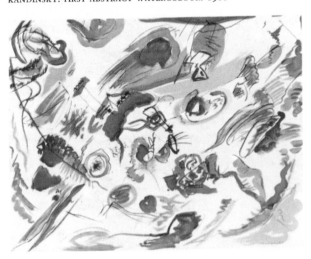

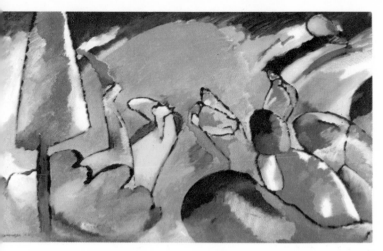

KANDINSKY. IMPROVISATION 14. 1910. M^{me} NINA KANDINSKY COLLECTION, PARIS

KANDINSKY. IMPROVISATION 30 (CANNON). 1913.
ART INSTITUTE, CHICAGO

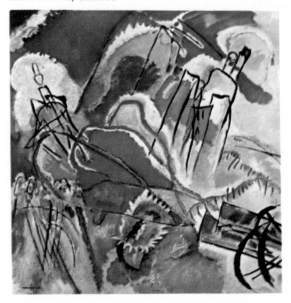

of colour flung impetuously on to the canvas. By 1960 his graphic style has become increasingly vehement, sometimes furious, and the picture is covered with scars, scribbles, a teeming mass of colours that seem in ferment. Amid the tangle of mingled tones and lines one can often make out rough, primitive faces part man and part beast, bewildered or demoniacal, expressing anguish or menace. And the atmosphere is much the same when the work is apparently non-figurative. Jorn may have certain affinities with Appel, but his art reveals more anxiety; there is less impertinence about the faces in his pictures, which have a certain pathos despite their grotesqueness and their sneering grins. Moreover, Jorn expresses himself less brutally than the Dutch painter, his colour shows more studied refinement; he is more unusual, less crude.

KANDINSKY Wassily (Moscow, 1866 - Neuilly-sur-Seine, 1944). Although he went to Munich to study in 1896, Kandinsky did not come into contact with Expressionism until 1908, after living for a year (1906-1907) at Sèvres, in Seine-et-Oise. He was doubtless influenced by the Fauves, of whose work he must have seen examples in Paris, for in most of the landscapes he painted in 1908 at Murnau in Bavaria his colour runs riot. He obviously had no cause to impose greater restraint upon it in 1909, when painting from imagination or from his memories of a visit to Tunisia four years previously. At the same time his form, which to begin with had been relatively sober, also began to reveal the artist's fiery temperament; the outline of objects alters, they vacillate, lean over and tend to collapse in a world which has only remote connections with external reality. Before long they fade out, and where they have not entirely disappeared they retain only a vague suggestion of what they were in nature. Kandinsky's first abstract work, a watercolour of 1910, consists only of hastily scrawled lines and patches of colour set on the paper with an impetuous yet groping hand. Henceforward, lines soaring up like rockets or zigzagging like lightning-flashes, glowing colours, dramatic clashes between different elements are not uncommon in his pictures, but by 1911 we find him seeking to control his verve and impose order upon his turbulent spontaneity. Naturally he is more disciplined in his *Compositions* than in his *Improvisa-*

tions. None the less, despite the fact that he strives to give greater precision to his forms and greater clarity to his structure, his works often remain involved, charged with emotive sonorities, shattered volumes, conflicting elements. In 1914 Kandinsky returned to Russia, where a few years later he asserted more strongly his desire to control the tumult of his early abstract works. The character of his art, however, did not really change until after he joined the Weimar *Bauhaus* in 1922, when he took to organizing strictly geometrical forms in a highly deliberate manner. He remained faithful to such forms until his death, but after leaving Germany in 1933 to settle at Neuilly, he began drawing them with greater fantasy and also, it would seem, with increasing serenity.

KIRCHNER Ernest Ludwig (Aschaffenburg, 1880 - Frauen-kirch near Davos, 1938). Kirchner was the richest and most complex personality among the young painters who founded the *Brücke* group at Dresden in 1905. We can distinguish various periods in his art, which correspond to the various stages of his life. His early work in Dresden reflects the interest he took first in the Impressionists and Neo-impressionists, then in Van Gogh, Munch, the art of black Africa and of Oceania, and finally in Matisse, but he quickly assimilated these influences so as to assert his individual characteristics. The figures and landscapes he painted towards 1906-1907 are made up of discontinuous brush strokes impetuously juxtaposed and clashing. Later the blobs of colour tend to broaden out into flat patches and the forms are firmly outlined. The dates inscribed by Kirchner on his paintings imply that this change of style must have taken place as early as 1906. But since Kirchner antedated a whole series of his pictures and repainted others, the works that bear the dates 1906 or 1907 were actually produced in 1909 or 1910; this has been conclusively shown by Donald E. Gordon, author of the latest monograph on this artist.

The themes he most frequently treated during these years were nudes, portraits, and scenes of street life, of the circus and the cabaret. The faces of the people walking down his *Street in Dresden* (1908) betray bewilderness and almost a touch of madness. Such painting inevitably recalls that of Munch,

KIRCHNER. SEMI-NUDE IN A HAT. 1911.
WALLRAF–RICHARTZ MUSEUM, COLOGNE

KIRCHNER.
GIRL ON
A BLUE SOFA.
FRÄNZI.
1907–1908.
INSTITUTE OF ARTS,
MINNEAPOLIS

although there is here less morbidity and a brighter palette. When Kirchner paints nudes, he deliberately gives them poses which suggest erotic situations. Yet his sensuality is never displayed without a certain bravado and a sense of remorse. Whether he shows men and women naked in a summer landscape or in a vividly coloured room, he seems unable to forget that they are breaking certain rules. When he paints dancers, he renders their movements by lines which twist but do not flow, and where the curves are cut short and broken by acute angles. He avoids anything that might give grace to his work, rejecting a beauty which would leave out of account the disquiet aroused in him by even the most seductive aspects of life. The same reason also dictates his choice of colours, their hard brilliance, their discordant stridency.

Towards the end of 1911 Kirchner settled in Berlin. Here, probably under Cubist influence, his form became more geometric, his palette more subdued, the structure of his pictures more apparent. He also elongates his figures, giving them greater elegance and flexibility. He shows them in the streets of Berlin, stressing the exaggerated *chic* of their dress, their slenderness, their affected walk, the make-up disguising women's faces, in a word everything that is unnatural, odd and provocative about them. The angularity and the hatched brushwork are evidence of continuing neuroticism, but nevertheless the paintings that Kirchner produced in Berlin are his most balanced, as well as his most original, works.

The 1914 war shook him to the very depths of his nature. Although he enlisted as a volunteer, he found soldiering so intolerable that he was invalided out in 1915 without ever having been to the front. For two years he was under medical care in Germany, then in 1917 he settled in Switzerland, near Davos, where he spent the rest of his life; he was by now almost paralysed, and psychologically in a state of complete collapse. When he was able to take up painting again, his art underwent a fresh change, more radical than that of his Berlin period but less happy. Now, in his paintings of the Alpine region and its people, he emphasizes the primitive character of the peasants but at the same time idealises their life as though to convince himself that health, and maybe happiness, lie there. Meanwhile he intensifies the height and inviolable splendour

of the mountains, and bedecks their steep sides with vivid and yet somewhat morbid shades of pink, orange and green. His nudes, now, lack the supple elegance of those he had painted in Berlin; they have also, for the most part, lost their eroticism. His urban scenes, too, are treated in a different spirit: the streets are filled now with an anonymous crowd of men, looking exhausted yet so drab that they fail to move us.

About 1930 Kirchner's art takes an unexpected turn. Influenced by Picasso, he seeks to paint in a freer and more abstract fashion, but when he simplifies his form to the point of schematism, making the patches of flat colour independent of the drawing, he goes against his own nature, so that these paintings fail to carry conviction. After 1935 he retraced his steps and went back to painting urban and Alpine scenes, but these added nothing noteworthy to his achievement either. Basically he was exhausted, riddled with disease, deeply depressed by political events in Germany; and his suicide in 1938 can be explained by this dejection, added to his state of health.

KOKOSCHKA Oskar (b. Pochlarn, Austria, 1886). Kokoschka spent his formative years in Vienna at the beginning of this century in a milieu still dominated by the *Jugendstil* of Klimt, although the examples of Van Gogh and Munch had already provoked a reaction against this among young painters such as Gerstl, who committed suicide in 1908 at the age of twenty-five. Kokoschka, himself influenced by Van Gogh and Munch, rejected the *Jugendstil*, whose decorative tendencies did not correspond either to his attitude to life or to his artistic preoccupations. His prime bent was to portraiture, and he did not confine himself to setting down the particular details of his sitters' faces; through these he revealed their hearts and their nervous systems. As he often painted his friends—the architect Adolf Loos, the writer Karl Kraus, the poet Peter Altenberg, and Herwarth Walden who, in 1910, persuaded him to live (for one year) in Berlin—he knows their characters, their inclinations, their excessive sensibility; he suspects their complexes, shares their anxieties, recognizes in them his own unease. Many of these faces reflect the ill-concealed anguish of a troubled mind, while the hands, too, suggest nervous tension, their long, slender, bony fingers seeming made only to register

KIRCHNER. THE AMSELFLUH. 1923

KIRCHNER. TWO NUDES. 1905.
WALTER BAREISS COLLECTION, MUNICH

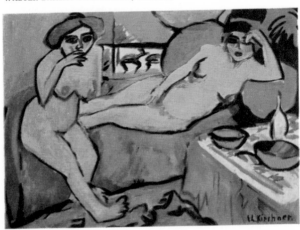

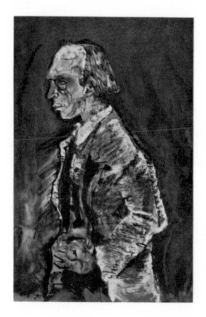

KOKOSCHKA.
PORTRAIT
OF HERWARTH WALDEN.
1910.
SAMUEL H. MASLON
COLLECTION,
MINNEAPOLIS

KOKOSCHKA. TOWER BRIDGE, LONDON. PRIVATE COLLECTION, HOLLYWOOD

77

painful sensations. It is impossible not to think of Freud, probing the depths of the human psyche, of all the dark, devious, powerful realities that he discovered there, whose existence man has found it so painful to admit. And it is impossible, moreover, not to think of Goya, who also disclosed, in the faces of his sitters, aspects about which they would doubtless have preferred to remain ignorant. But to speak of expression in connection with Kokoschka means considering not only faces and hands, but drawing and colour as well. His forms are defined by a sinuous line, incisive and often incised, meanwhile retaining all their vibrancy; while his colour, which is not bright, gives the faces the throbbing look of flayed flesh.

Towards 1912 Kokoschka's brushwork grows broader and colour takes on greater importance, while his impasto becomes heavier. During his liaison with Alma Mahler, widow of the composer Gustav Mahler, he painted a number of pictures that reflect the tensions of his relations with her. The 1914 war, in which he was seriously wounded (1915), increased his pessimism, and in his *Self-portrait* of 1917 a tormenting anxiety is revealed not only by the face but by the convulsive handling. In other works of the same period the writhings and spasms of the form are emphasized by the uneasy character of the colour

KOKOSCHKA. PEN AND INK STUDY. 1919

(*The Friends*, 1917-1918). In 1919 Kokoschka was appointed professor at the Academy of Dresden, and during the next few years he painted views of that city, as well as human figures, treating both in a broad style, using purer and more resonant colours and spreading them in wider zones. His post at the Academy did not however allay his basic restlessness and his thirst for independence, and in 1924 he fled from Dresden and travelled widely; between 1924 and 1934 he stayed in Paris, Bordeaux, Madrid, London, Amsterdam, Venice, Lyon, North Africa, Ireland, Egypt, Istanbul, Jerusalem, Vienna and elsewhere. He naturally continued working during these travels; in particular, he painted urban landscapes, usually from a bird's eye view which allows him to survey the scene in breadth and in depth. In his paintings he always suggests the animated life of these towns, not by introducing a great many figures—often he shows merely a huddle of houses, with a few birds in flight in the sky—but essentially by means of his tense, swift handling. However picturesque, however splendid the scene before him, it cannot quieten his nervous tension; his psychological yearning remains forever unsatisfied.

Political events in Germany and Austria drove Kokoschka to take refuge first in Prague (1934) and then in England (1938), and until 1953, when he settled at Villeneuve in Switzerland, he lived chiefly in London. His style, however, changed little henceforward, except that his colours become lighter and his draughtsmanship even sketchier and more impetuous. Although he never recovered the depth and density of his earliest works, he went on painting portraits and landscapes, but he also portrayed a number of allegorical scenes (*Prometheus*, 1950; *Thermopylae*, 1954). Of course history and mythology were for him only a means to communicate some "message" to his contemporaries, to remind them in particular of the dangers incurred by man through his own rashness and through the destructive invasions of barbarism. These compositions are therefore crowded with figures and ideas, and in this respect, as well as through his manner of painting, Kokoschka henceforward shows his kinship to the baroque painters who decorated churches and palaces.

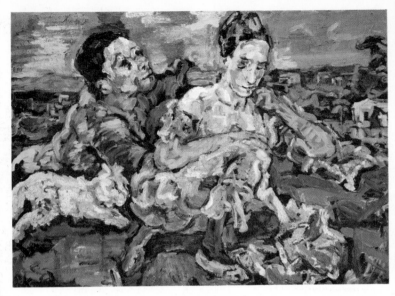

KOKOSCHKA. LOVERS WITH A CAT. 1918. KUNSTHAUS, ZÜRICH

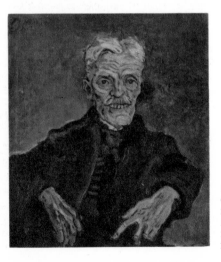

KOKOSCHKA.
OLD MAN:
FATHER HIRSCH.
ABOUT 1907.
NEUE GALERIE,
LINZ

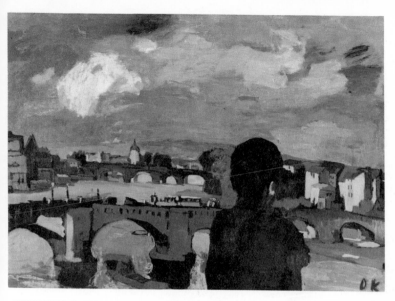

KOKOSCHKA. BRIDGES OVER THE ELBE IN DRESDEN. 1923.
FOLKWANG MUSEUM, ESSEN

KOKOSCHKA.
PORTRAIT
OF ELSE KUPFER.
1910.
KUNSTHAUS,
ZÜRICH

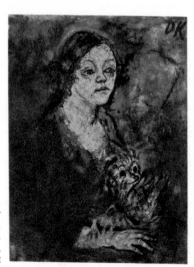

KOONING Willem de (b. 1904 at Rotterdam). While training as a house decorator he attended evening classes at the Academy of Rotterdam until 1920. Four years later he spent some time in Belgium, and there no doubt became acquainted with Flemish Expressionism, although this cannot be said to have had any immediate influence on him. In 1926 he emigrated to the United States, where he became close friends with Arshile Gorky. His expressionist tendencies had already been revealed during the second world war; by 1945 they had become more marked, and after 1950 took on a harsh and violent form. It was now that he painted a series of female figures with grossly deformed bodies and wild, grinning, lunatic faces. The violence of his brushwork gives them a sketchy look, as though the artist's contempt or disgust had prevented him from completing his work. The clear, pale, delicate colours (including a great deal of lilac) do not diminish the unease one feels in the presence of these monstrous beings. Towards 1965 de Kooning painted other female figures with less hideous faces but equally misshapen bodies. He also produced some non-figurative works, which display the same impetuous handling (akin to action painting), the same rejection of clearcut forms and often the same predilection for sweetish tints. In certain pictures, particularly those painted about 1959, we do indeed find broader stretches of colour, sustained and contrasted tones and a more visible structure, but the deliberately loose handling none the less reflects the violence and impatience characteristic of this artist.

KRUYDER Herman Justus (Lage Vuursche, Netherlands 1881 - Amsterdam, 1935). He began first as a house painter, then towards 1900 he studied at the School of Arts and Crafts of Haarlem in 1900 and then went to work in a stained glass artist's studio at Delft. Towards 1910 he settled in Haarlem and decided to devote himself exclusively to painting, but his originality did not assert itself until some ten years later. From 1916 onwards he lived in the villages of Heemstede, Bennebroek and Blaricum, where he painted chiefly rural subjects (a pig-butcher, a milkmaid, a blacksmith, a cock, a calf, a stallion). His chief characteristic is a tendency to make his human and animal figures unnaturally short and squat, so

that they look like toys or peasant ceramics. But though his forms are clumsy and rudimentary, Kruyder's colour shows variety and subtlety and he has turned to good account his practice in the field of stained glass. Moreover, his painting conveys a sense of disquiet, above all by the way his figures look at us with huge staring eyes.

KUPKA Frank (Opoczno, Bohemia, 1871 - Puteaux, 1957). Kupka, who settled in Paris in 1894, was only connected for a short while with Expressionism; at the start of his career he was influenced by the *Jugendstil*, and by 1911 he had abandoned representation and was painting abstracts. If he is mentioned in this book it is on account of the pictures he made about 1909, in the vein of Toulouse-Lautrec rather than of Rouault, representing prostitutes in the street or in an interior. Their bodies concealed by showy garments, they seem at once alluring and indifferent, provocative and cynical, willing to seduce yet prepared to protect themselves. The drawing is harsh and deliberately somewhat awkward; the colour shows an unexpected combination of aggressiveness and distinction.

KUTTER Joseph (Luxemburg, 1894 - Luxemburg, 1941). When he discovered his propensity towards Expressionism Kutter was still living in Munich, where he had studied at the Academy (1917-1918). In 1924 he returned to Luxemburg and thenceforward rejected the stridencies of colour which had implied a certain kinship with the German Expressionists. He still made use of rich tones, but they became deeper and more unusual. Some of his landscapes by their subject may remind one of Vlaminck's, but in contrast with the latter's impetuosity Kutter spends a long time working at his paintings, avoiding the slapdash as much as the finicky. He also differs from Permeke, of whom the solid monumentality of some of his figures may remind us; his palette is more complex than that of the Belgian painter and there is nothing brutal about his distortions. Up till 1932, his figures give little indication of any inner life. A yawning woman, a woman with a flower, a servant girl, a woman leaning on her elbows—they are all a little drowsy, their faces betray indolence or lassitude. Even the *Man with an injured finger* (1930) looks completely impassive; what counts

83

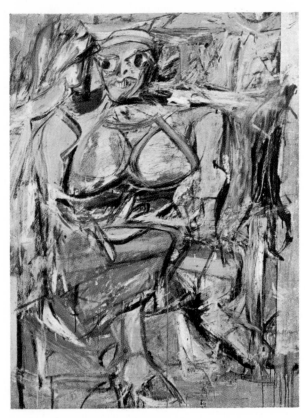

DE KOONING. WOMAN I. 1950–1952.
MUSEUM OF MODERN ART, NEW YORK

DE KOONING.
MERRITT PARKWAY. 1959.
SIDNEY JANIS GALLERY,
NEW YORK

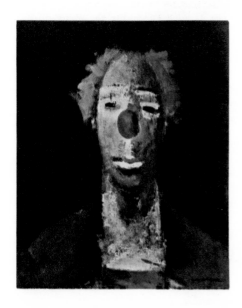

KUTTER.
CLOWN.
PRIVATE
COLLECTION

in these paintings is not the subject but the treatment of the composition. From 1932 onwards, however, Kutter began to embody ideas and feelings in his figures, which generally stand in the foreground of his pictures, motionless and imposing. The *Clowns* which he painted from 1936 to 1938 are in fact self-portraits; they reveal in a startling fashion the physical and mental agony inflicted on him by an illness which was to torment him until his death. None the less he continued to elaborate his works with relentless deliberation; his form remains vigorously constructed, his brushwork careful and his texture attractive. Furthermore, although Kutter's illness imparted a sense of sadness, almost of desolation, to all the faces he was to portray henceforward, it did not dull his palette. On the contrary, he intensified the flower-like brightness of his foreground tones against the sombre colours of his backgrounds. His landscapes became expressionist before his figure-paintings, and remained so till the end of his life. Whether his subjects are suggested by Venice, Saint-Tropez or Calvi (1927-1933) or, in his later work (1934-1940) by Luxemburg, Germany and the Netherlands, these landscapes express his painful and somewhat anguished state of mind rather than the reality of the external world.

LE FAUCONNIER Henri (Hesdin, Pas-de-Calais, 1881 - Paris, 1946). Le Fauconnier, who studied in Paris in the early years of this century under J.-P. Laurens and at the Académie Julian, from 1909 onwards formed part of the Cubist group of Montmartre which included, notably, Delaunay, Léger, Gleizes and Metzinger. In 1910 we find him among the supporters of the *Neue Künstlervereinigung* (New Association of Artists) of Munich, by the side of Kandinsky and Marc. His fame was so great in Germany at that time that two of his works were reproduced in the Almanach of the *Blaue Reiter* (1912) and praised by Kandinsky himself. Yet he cannot be considered a very daring Cubist. In 1912, Le Fauconnier taught in Paris at the Académie La Palette, where Gromaire was one of his pupils. A year later he was converted to Expressionism. At first he retained a liking for simplifications and, seeking to accentuate the austere character of the women of Zeeland whom he painted in Holland in 1914, he not only used dark colours but

gave a somewhat harsh geometrical quality to his volumes. Shortly afterwards, however, he turned to a more realistic manner, which became more marked when he went back to Paris in 1920. Meanwhile he enjoyed as much prestige in Holland as he had in Germany, and influenced not only such Dutch painters as Sluyters, Piet and Mathieu Wiegman, but also the Flemish refugees, Gustave de Smet and Van den Berghe, whom he helped to direct towards Expressionism. All things considered, his importance lies less in his own painting than in the part he played before 1920 in influencing other artists.

LORJOU Bernard (b. 1908 at Blois). For many years Lorjou, who was selftaught, painted in a rough, emphatic, realistic style, tending towards caricature. The influence of Van Gogh, and that of Vlaminck in his Fauve period, is shown by his love for pure colours, his own being bright to the point of aggressive crudeness. A rebellious, combative spirit, enamoured of hugeness and grandiloquence, he often chose contemporary themes, political or otherwise, for his large-scale paintings, and a recent series deals with *The Murder of Sharon Tate*. Here, remembering Picasso, he makes use of a more modern style than that which was formerly characteristic of him. In contrast with the violent expressionism of his draughtsmanship, where sharp black lines stand out against a light background, he introduces decorative elements which at first sight seem foreign bodies in such art. On reflection, one sees the connection between their falsely idyllic, masquerade-like character and the world of hippies and drug addicts. If in these paintings the colour is less crude than in his earlier canvases, it none the less includes bright pink and orange tints that are harsh and glaring.

MARYAN (b. 1927 at Nowy-Sacz, Poland). His real name is Pinchas Burstein. Maryan, a Polish Jew, spent the war in Nazi concentration camps, and the years 1945 to 1947 in refugee camps in Germany. Between 1947 and 1950 he lived in Israel. Since then he has made his home in Paris, where he studied for three years at the École des Beaux-Arts. The sufferings he endured in the camps, the tragic, mutilating experiences he underwent explain the presence in his work of so many

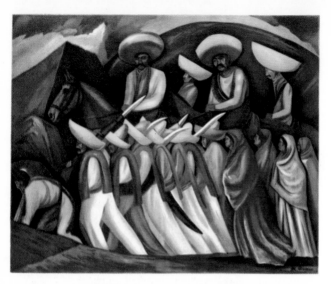

OROZCO. ZAPATISTAS. 1931. MUSEUM OF MODERN ART, NEW YORK

RIVERA. ARUMS. PRIVATE COLLECTION

SIQUEIROS.
THE ECHO OF A CRY. 1937.
MUSEUM OF
MODERN ART,
NEW YORK

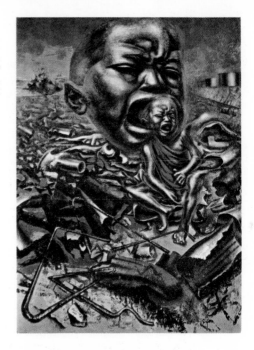

TAMAYO. ANIMALS. 1941. MUSEUM OF MODERN ART, NEW YORK

creatures with faces distorted in anguish, with the attitudes of puppets or of cripples, clad in rags or in carnival fancy dress. Painted in a manner which shows the influence of Chagall and Picasso, these figures evoke with painful bitterness the misfortunes and terrors of a world under the sway of madness.

MEIDNER Ludwig (Bernstadt, Silesia, 1884 - Darmstadt, 1966). After studying at the Academy of Breslau (1903-1905) he settled in Berlin, and in 1907 joined the group which had been formed around the Expressionist journal *Die Aktion*, and designed title-pages for that publication. The pictures he painted before the 1914 war, with their jerky, jagged, breathless draughtsmanship and their deliberately startling colour, depict a world in the throes of an earthquake. His houses are askew, his skies streaked with rents, his figures agitated and bewildered, terrified or mad with rage: Meidner at this period tells only of chaos resulting now from political conflicts, now from cosmic disasters. In 1916 he was mobilised, and when he resumed his painting after 1918 it no longer reflected the apocalyptic temper of the earlier works, which make him one of the more frenzied exponents of Expressionism.

MEXICAN EXPRESSIONISM. A variety of factors account for the development in Mexico of an Expressionism which in some ways is very different from that which we know in Europe: first, the atmosphere of political excitement generated by the revolution of 1910; secondly, an old national tradition whose expressionist tendency is unmistakable, particularly in the art of the Zapotecs and Aztecs; finally, European influences combined with autochtonous tendencies. Three artists are usually cited as representing Mexican expressionism: Diego Rivera (1886-1957), José Clemente Orozco (1883-1949) and David Alfaro Siqueiros (born 1896). To these we may add Rufino Tamayo (born 1899), although his art bears little relation to theirs. All these painters were commissioned to create huge mural compositions telling of Mexico's past or of contemporary history, particularly of revolutionary episodes. Hence the necessity of depicting a large number of figures in varying attitudes; hence, too, in the case of the first three, an epic narrative style which does not always avoid bombast or

brutality. In other respects, these four artists by no means use identical methods. Rivera, who while working in Paris (1911-1920) became interested in Cubism, and who during a visit to Italy in 1919 made a special study of Giotto's frescoes in Padua, reminds us in some of his large compositions of Gauguin and of Henri Rousseau as well as of Mexican folklore. His illustrative style, in fact, shows few characteristics that can really be called expressionistic. Siqueiros, on the contrary, who suffered exile and imprisonment in consequence of his participation, as a militant Communist, in the day-to-day political struggle, produced vehement, aggressive, obsessive works that are deliberately disturbing in their impact rather than simply moving. Inspired by such old masters as Masaccio and Signorelli, as well as by the images of contemporary photography, he makes use of realistic elements, but assembles them with a freedom that shows his acquaintance with Surrealism. Orozco, whose forms are harshly simplified and whose colour has a strongly emotive quality, appears to owe little to Europe; while Tamayo, who would not have been what he is without Picasso, remains none the less profoundly Mexican in his colour as well as in his themes. He did paint many easel pictures, however, which were often exhibited in Europe. It is interesting that these four Mexican artists worked in the early thirties in New York, which accounts for their influence on certain American painters: Pollock made a particular study of the work of Orozco and Siqueiros.

MODERSOHN-BECKER Paula (Dresden, 1876 - Worpswede, 1907). This artist is commonly included among the precursors of Expressionism, but this can only be justified to the (very slight) extent that the same claim can be made for Cézanne and Gauguin. It was, in fact, the work of these two masters that served her as models during her various visits to Paris between 1900 and 1906. Towards the end of her life, the influence of Gauguin becomes particularly evident, both in the simplified forms and in the flat tints which she uses to paint her self-portraits, her mothers and children, her flowers and still lifes. However, Paula Modersohn-Becker has individual qualities too: her colour is distinguished by its sobriety and restrained warmth, and she evinces an ardent sympathy for the

MODERSOHN–BECKER. NUDE GIRL WITH FLOWERS. 1907.
VON DER HEYDT MUSEUM, WUPPERTAL

MODIGLIANI.
PORTRAIT OF SOUTINE.
1917.
STAATSGALERIE,
STUTTGART

MODIGLIANI.
SEATED NUDE. ABOUT 1917.
COURTAULD
INSTITUTE OF ART,
LONDON

MODIGLIANI.
PORTRAIT OF
ZBOROWSKI.
1917.
MUSEU DE ARTE,
SAO PAULO

human beings and objects that she paints.

MODIGLIANI Amedeo (Leghorn, 1884 – Paris, 1920). Of all the *"peintres maudits"*, the doomed painters who came to work in Paris at the beginning of this century, Modigliani is the one whose art and personality have had the greatest appeal to the general public. For one thing, he was handsome, tubercular and poor, and after an excessive indulgence in alcohol and

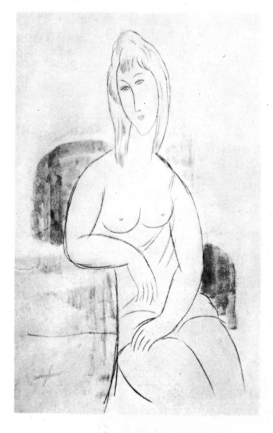

MODIGLIANI. SEATED WOMAN

drugs he died young in a hospital bed. Furthermore, it is difficult not to respond to the nostalgia which pervades his art. When he came to Paris about 1906 he had studied in the art schools of Leghorn, Florence and Venice, and he was never to forget the Tuscan masters of the fourteenth and fifteenth centuries whom he had studied in Italian museums. After living for a while in Montmartre, where he was in contact with the Bateau-Lavoir group, the future Cubists, he settled in Montparnasse in 1909. An admirer of Cézanne and Matisse, he was well aware of the expressive potential of pure relations between geometricized forms. When therefore he elongates figures, necks and faces he is not always impelled by expressionist motives. Furthermore, his art is devoid of any frenzy; his touch is never impetuous, his colour neither loud nor arbitrary. From 1911 onwards he shows himself essentially a draughtsman, surrounding every form with a clear, sometimes incisive, and increasingly flowing line. Modigliani's painting is at once elegant and somewhat morbid, touching rather than moving, and mannered rather than inventive; it is more disciplined than that of his friend Soutine, but it has less density and diversity. Nevertheless he created a series of portraits and nudes which are completely individual. In both cases he expresses chiefly his own weariness and melancholy. Thus we recognize languor, depression and anxiety even in the nude female figures which seem fully aware of their own attractiveness and of sensual pleasure.

MUELLER Otto (Liebau, Silesia, 1874 - Breslau, 1930). He studied at the Art Academy of Dresden from 1896 to 1898. In 1908 he went to live in Berlin and two years later joined the *Brücke* group, although his art was never aggressively expressionistic. Otto Müller is fond of painting slender, graceful girls, attractive and yet distant, showing no wish to exercise their powers of seduction. Whether they appear in an interior or in a landscape they reflect a wholly natural "paganism", yet at the same time betray a secret unease. These charming bodies seem unacquainted with the delights of sensual pleasure, knowing only its weariness and melancholy. The glances that escape from under their long eyelids are drowsy and shyly questioning; their delicate mouths, one feels, can utter only

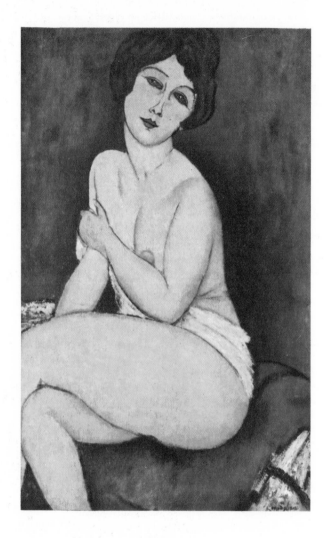

MODIGLIANI. SEATED NUDE. 1917.
G. RENAND COLLECTION, PARIS

MUELLER.
NUDE GIRLS.
WALLRAF–RICHARTZ
MUSEUM, COLOGNE

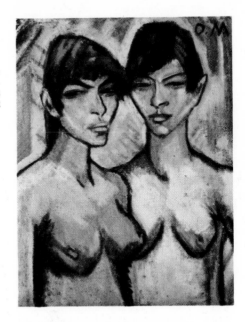

MUELLER. TWO GIRLS IN THE OPEN AIR. 1925.
BAYERISCHE STAATSGEMÄLDESAMMLUNGEN, MUNICH

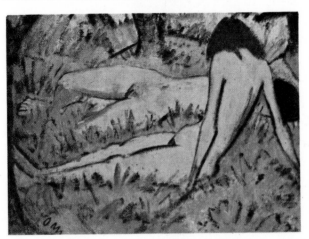

plaintive or embittered murmurs.

Otto Müller's colour is also highly individual. Devoid of any violence, it is further subdued by the artist's technique: he paints with glue on jute canvas, which produces a rough, matt surface and a somewhat austere effect. Müller declared in 1919 that in matters of technique he had modelled himself on the paintings of ancient Egypt. He might have added that even the faces of his girls, particularly their eyes, recall the young women depicted on the tombs of the New Empire. On the other hand, he reveals a certain debt to Cubism in the geometrical character which, towards 1912, his forms assume. Later his lines were to evolve in a freer fashion, but on the whole his style varied very little. His colour grew somewhat warmer after 1918, when he chiefly painted gipsies. His interest in these was so considerable that to study their way of life he repeatedly visited Yugoslavia, Romania and Hungary. And once again choosing as models girls or young mothers holding their babies, he portrayed with a sympathy tinged with romanticism their rhomboid faces, their triangular chins, their black eyes, their feline glances that suggest that these enigmatic creatures are under the sway of the irrational. When they are not nude, his women wear lilac dresses, yellow blouses, pink skirts with blue stripes; and these colours emphasize their swarthy skins and their exotic features.

MUNCH Edvard (Löiten, Norway, 1863 – Ekely near Oslo, 1944). Munch already had several years' study in Oslo behind him when in 1885 he went for the first time to Paris, where he became interested in the Impressionists. He went there again in 1889 and stayed until 1891; this time he discovered Seurat, Van Gogh and Gauguin. It was after his return to Oslo that his art assumed the expressionist character which was to bring him fame, and the tone of which had already been suggested in several of his works. It can be accounted for, in the first place, by his life story. While still a child he lost his mother and one of his sisters, both victims of tuberculosis. His own health was precarious, while his father, a doctor working among the poor, was subject to neurotic anxiety. When we consider further that in 1886 Munch belonged to the "Bohemian" set in Christiania, and that a few years later, in Berlin,

MUNCH. THE SHRIEK.
1893.
LITHOGRAPH

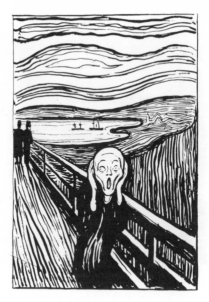

he was in contact with Strindberg and the Polish poet Przy-byszewski, we can imagine the kind of feelings and ideas which were familiar to him.

For Munch, man is doomed to solitude and anguish. He feels as isolated and uneasy in a crowd as when he confronts nature alone and, panic-stricken, howls like a beast (*The Shriek*, 1893). Sometimes ravaged by illness, sometimes stricken by a bereavement, he has the sad and often haggard look of one who can never be comforted. The citizens in the *Karl Johans Gate* (1892) are like spectres, terrified and terrifying. Even love, by which Munch was much preoccupied, meant for him a source not of consolation but of torment and bitterness. Woman not only provokes desire and jealousy; she bewitches and exhausts her lover, sucks his marrow, as Baudelaire put it, and finally flings him back into a void where he is left with nothing but vain memories and regrets. Meanwhile she, too, is dissatisfied and unhappy.

It is significant that as early as 1889 Munch conceived the idea of inviting the spectator to view his pictures not merely in

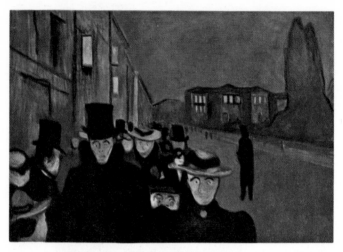

MUNCH. THE KARL JOHANS GATE. 1892.
RASMUS MEYER COLLECTION, BERGEN

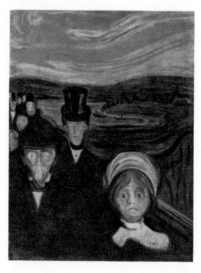

MUNCH.
ANXIETY.
1894.
MUNICIPAL
COLLECTIONS,
OSLO

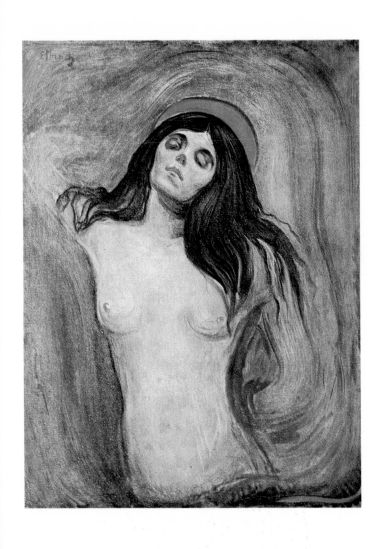

MUNCH. MADONNA. 1894-1895. NASJONALGALLERIET, OSLO

isolation but as a whole, as the *Frieze of Life* which they consti-
tute. In order that this Frieze might some day be exhibited in
its entirety, he painted replicas of the pictures he had sold, so
that he sometimes repeated the same painting after an interval
of several years.

Munch also painted portraits, and when his model is one of
those Norwegians who are remarkable for their vigour, their
powerful build, their love of action, he does not attempt to
understate the sitter's vitality, but on the contrary stresses it,
conveying the full strength and solidity of the big man. On the
contrary, when the picture is a self-portrait it has a very different
look, suggesting neurotic anxiety.

As for Munch's style, it reflects certain tendencies of the
late nineteenth century. The slowly sinuous lines are akin to
Art Nouveau, and there is an element of symbolism about his
colour. This painter might have said like Van Gogh: "I have
tried to express with red and green the terrible passions of
mankind." Not that his palette is as pure as that of his pre-
decessor. He uses broken tones more often than pure colours,
because they convey his melancholy better.

An exhibition of Munch's paintings in Berlin in 1892 pro-
voked a scandal which established his fame and encouraged
him to settle in the German capital. But in 1895 and 1896 he
went back to spend a few months in Paris, where he mingled
with the artistic avant-garde and designed the sets for a pro-
duction of Ibsen's *Peer Gynt* at the *Théâtre de l'Œuvre*. Shortly
before this (1894) he had begun to produce engravings, and
these were to form an important part of his work. In general,
they are more sharply expressive than his paintings, and this is
the more easily observed since he often treats the same theme
in the two different media.

Munch's first Expressionist period, and that which was to
prove the most important in the history of art, ended in 1908.
The artist then left Germany, and after having been obliged by
a serious attack of nervous depression to seek treatment in a
Copenhagen nursing home, he returned to Norway in 1909.
Henceforward his art appears to be less charged with anxiety.
His colour becomes lighter and his impasto even thinner and
more fluid than it had been hitherto, so much so that some of
his oil paintings look almost like watercolours. Apart from his

replicas of earlier works, Munch henceforward painted chiefly nudes, children, peasants and workmen. His figures are still grave and thoughtful, but seem no longer consumed by anguish. Yet when, in his self-portraits, he records the effects of old age—the sunken features, the flabby flesh, the accumulation of bitterness around the mouth—we realise that his mind had not attained that peace that other works might suggest.

NOLDE Emil (Nolde, Schleswig, 1867 - Seebüll, 1956). When Emil Hansen, who adopted the pseudonym Nolde in 1901, joined the *Brücke* group in 1906, he was nearing his fortieth year. He had been painting for a number of years but had not yet found his own style, and he was only converted to Expressionism after leaving the group in 1907. It was nevertheless his contact with Kirchner, Heckel and Schmidt-Rottluff that impelled him to abandon his earlier manner, which was more or less Impressionist. At all events, under the influence of Munch and of Van Gogh he began, towards 1909, to express the visions suggested by his religious feeling and, more generally, his own highly-strung and untamed nature.

Whether his theme is *Pentecost* (1909), *The Last Supper* (1910), or *Christ blessing the Children* (1910), *Joseph telling his dreams* (1910) or *The Life of St Mary the Egyptian* (1912), Nolde always shows human beings as primitive and even coarse. His Christs, his Apostles, his female saints and even his princesses are wild rustic creatures, passionate and ecstatic. Their faces are merely masks, roughly sketched out and aggressively bright in colour. Perhaps Nolde meant by this means to segregate his themes from everyday life, giving them that legendary aspect that befits Biblical scenes; yet he deals in the same fashion with secular, contemporary subjects: girls dancing round candles, or men drinking wine in a Berlin café—although in the latter case rusticity is replaced by neuroticism and moral decadence. Moreover, this painter is never satisfied with merely showing us his images; he hurls them at us, he wants them to strike us with the utmost force and directness. Hence this orgy of loud colours, jarring and clashing; hence, too, his impetuous handling, the crude, heavily impasted quality of his paint. Hence, finally, his draughtsmanship, which diverges from the realist tradition only by its rough, rudimentary, caricatural character.

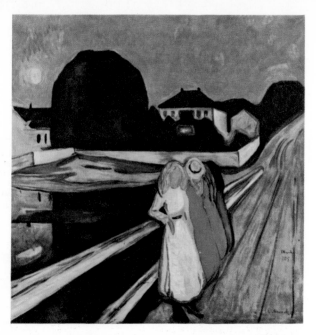

MUNCH.
FOUR GIRLS
ON A BRIDGE.
1905.
WALLRAF–RICHARTZ
MUSEUM, COLOGNE

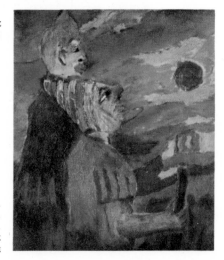

NOLDE.
THE TRAMPS.
1910–1915.
WALLRAF–RICHARTZ
MUSEUM, COLOGNE

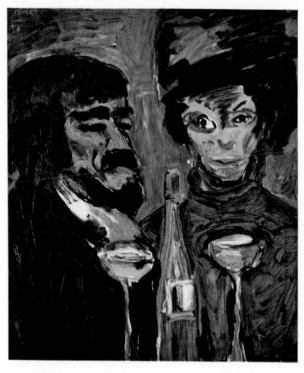

NOLDE. SLOVENES. 1911. ADA AND EMIL NOLDE FOUNDATION, SEEBÜLL

NOLDE.
LUNCH PARTY.
1907.
WALTER BAREISS
COLLECTION,
MUNICH

NOLDE.
YOUNG COUPLE. 1913.
LITHOGRAPH

In 1911 Nolde went to visit Ensor at Ostend, and in the Netherlands he became enthusiastic about Rembrandt and Frans Hals. In 1912 he settled in Schleswig, first at Utenwarf and then, after 1927, at Seebüll. He loved the landscape and the loneliness, which did not, however, prevent him from spending almost all his winters in Berlin, up till 1940. In 1913 and 1914 he made a long voyage to Oceania, which, while providing him with a number of subjects, did not transform his manner. There is no considerable difference, either, between the paintings of 1918 and those of 1929 or 1933. It was only towards the end of his life that Nolde tended to tone down the violence of his palette.

Besides the works in which exaggerated emotionalism or theatrical fantasy prevail, he produced others in which his imagination is more controlled. These are either portraits or paintings of a few human beings bound together by natural affection. Here he displays a certain objectivity, and while his colours are still freely chosen, they are less strident. He often paints flowers and landscapes; here, objects are frequently reduced to patches of colour as brightly glowing as in most of his figures: his flowers blaze, and skies of mingled red and orange, green, violet and brown lour oppressively over the heavy seas, the houses huddled on the plain or the bleak,

uneasy silhouettes of windmills.

Apart from these, Nolde painted a number of watercolours which, while less "ambitious" than his oil paintings, less charged with ideas and "messages", have more attractive painterly qualities. True, even here his drawing does not always avoid the facile effects of sentiment and caricature. But the same tones which in his oil painting assume a brutal brilliance are softened; they blend instead of clashing; their sonorities are still dense, but no longer painful. We find here, moreover, tints that are vaporous and transparent, resonances that are rich and unusual, an original and immediately appealing vein of poetry. In short, in Nolde's watercolours the artist's qualities are equal to the visionary's.

PASCIN Julius Mordecai Pincas, known as Jules (Vidin, Bulgaria, 1885 - Paris, 1930). His father was a Jew of Spanish origin, his mother an Italian; Pascin was the typical cosmopolitan painter. He spent part of his childhood in Bucharest, studied in Vienna, lived from 1902 to 1905 in Budapest, Vienna, Munich and Berlin, attended various art schools and finally came to Paris in 1905. Later he was to live in Brussels, London and the United States (1915-1920) before returning to Paris, where he spent the rest of his life, apart from various journeys and another visit to the U.S.A. in 1927-1928. His favourite subject were nude or semi-nude female figures in erotic attitudes and settings. There is generally a suggestion of melancholy about these figures, as though the pursuit of love brought them more weariness than delight. Pascin himself became so disillusioned with life that he committed suicide. As for his style, his colours are never brilliant, but gradually become more muted and hazy. His forms, which towards 1910 were defined by a firm yet flexible line, become more geometrical towards 1916 and are finally merely suggested by blurred modelling and a delicate contour.

PECHSTEIN Max (Eckersbach near Zwickau, 1881 - Berlin, 1955). After studying at the Dresden Academy Pechstein joined the *Brücke* group in 1906. Two years later, having visited Paris where he made friends with Van Dongen and was influenced by Matisse, he settled in Berlin. While the

PASCIN.
NUDE IN RED
SANDALS. 1927.
OSCAR GHEZ
MODERN ART
FOUNDATION,
GENEVA

PECHSTEIN.
THE ARTIST'S
WIFE. 1910.
WALLRAF-RICHARTZ
MUSEUM, COLOGNE

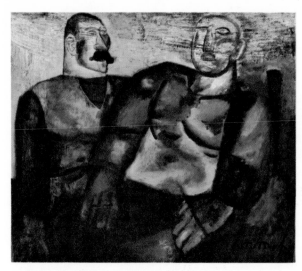

PERMEKE. TWO SAILOR BROTHERS. 1923.
KUNSTMUSEUM, BASEL

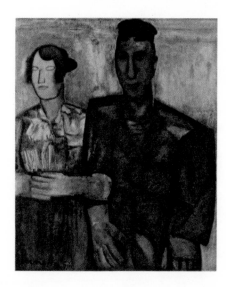

PERMEKE.
ENGAGED COUPLE.
1923.
MUSÉE D'ART
MODERNE,
BRUSSELS

109

colour in his landscapes, his pictures of women bathing, his portraits and still lifes does not lack vividness, his form—despite certain simplifications—remains essentially realistic. Pechstein is reluctant to discard modelling; his distortions stop short of excess; he seldom deviates from traditional rules of space construction. It is thus not surprising that he began by being the most acceptable Expressionist in Germany; his painting shocked people less than that of his associates in *Die Brücke* because it was less unusual; his subjects are akin to theirs, but he treats them in a less startling and therefore less aggressive and uncompromising fashion. And he was the more likely to appeal because his sensuality was frank and uncomplicated, without subtlety but without a trace of morbidity. While Pechstein continued to paint until the end of his life, his most expressionist period, which is also the most interesting, was that prior to 1914.

PERMEKE Constant (Burght on the Scheldt, near Antwerp, 1886 - Ostend, 1952). Permeke painted his first Expressionist works in 1913 at Ostend, doubtless inspired by the example of Servaes. He became acquainted with the latter at Laethem-Saint-Martin, where he lived from 1909 to 1912, after studying at the Academies of Bruges and Ghent. Mobilised in 1914, he was seriously wounded near Antwerp and evacuated to England. These experiences intensified the tendency he had already begun to show in Ostend, and in 1916-1917 he painted landscapes and country scenes which display an unbridled vehemence. However, *The Stranger* (1916) is closer to the style which was to make him famous. Here the human figures, grouped against back-lighting or bathed in a yellowish glow, are solid and robust; the picture is strongly built up, the paint is laid on with a full brush, and the colour is grave and, though lacking in variety, it has warmth.

Permeke returned to his native land before the end of 1918, and soon became the chief pioneer of that Expressionism which, firmly rooted in the soil of Flanders, was now developing in Belgium. The rich browns of a newly ploughed field, the colder browns of old wood, polished and dignified by long use, the yellows of clay or straw, the greens of water-logged meadows, the white of milk or of peeled potatoes: such are

the colours which make up his habitual palette. Sometimes a tone may suggest a more precious material, gold or ivory, without conferring the slightest hint of preciosity upon the work. For the hint of gold is found in a stable reeking of dung, that of ivory in a newspaper or an earthenware jug.

As for Permeke's draughtsmanship, in 1920 it had a certain flexibility; shortly afterwards it began to grow stiffer and harder, and under the influence of Negro sculpture the artist geometricized his forms in a ruthlessly radical fashion. By 1923 they had become rougher and more summary, and as he liked to set his figures against a light background, their massive character is emphasized at the same time that their faces become more indistinct and therefore stranger. After 1932 his geometrical rigour is relaxed and his distortions become less violent.

Permeke's subjects were drawn from the milieu in which he lived. When he went back to Ostend after the war he painted fishermen, boats, the sea and the harbour. After 1925, when he settled in the village of Jabbeke near Bruges, he took his themes from rural life. But whether he paints fishermen or peasants, men or women, he shows them as uncouth beings with heavy bodies and strong, coarse, calloused hands. Permeke's world is one of joyless drudgery. His fishermen and his boatmen are committed to strenuous labours; his peasants are forced to scrape the soil in attitudes that make them look like great insects. Moreover, when they are not standing upright in the foreground, so that their great bodies fill up the picture, they lose their sturdiness and become creatures without individuality, doomed to exhausting toil. Woman's fate is, furthermore, to experience all the discomforts of fertility; Permeke's female nude has heavy breasts, a swollen belly, melancholy eyes and an uneasy mouth. He also paints other nudes which might be pretty if the sombre colour did not cancel out the charm of their figures. But they are exceptions, and these nudes touch one less than the others, since basically prettiness is alien to Permeke's temperament.

The truth is that he was never better inspired than by ugly or trivial things. Some of his finest paintings have for their subject a cow and her calf in their shed, or a sow and her piglets in a farmyard. In any case, the subject may be trivial but the painting never is. For Permeke looks at life with a fervent gravity that

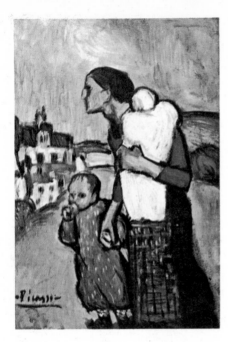

PICASSO.
THE MOTHER. 1901.
CITY ART MUSEUM,
SAINT LOUIS, U.S.A.

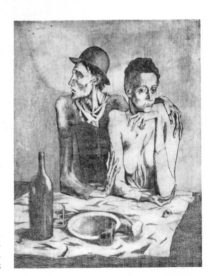

PICASSO.
THE FRUGAL REPAST.
1904.
ETCHING

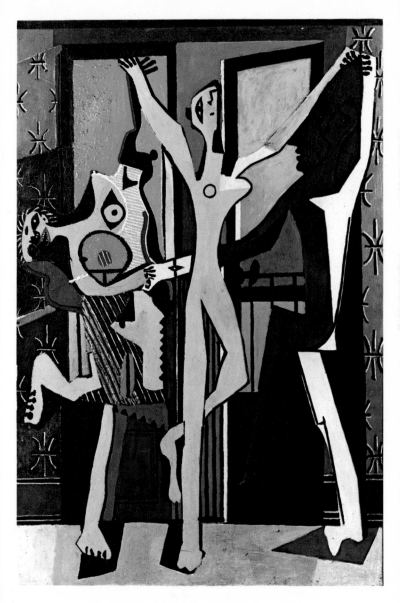

PICASSO. THREE DANCERS. 1925. TATE GALLERY, LONDON

is almost religious. To these ungainly figures gathered round their meal of black bread, herrings or potatoes, a meal is just the fulfilment of a need, but at the same time it becomes almost a ceremony.

In Permeke's landscapes the forces of nature are often let loose to darken the skies, to whip up the sea, to sweep wildly over the plains; and when they are held back, their restraint holds a secret menace. Permeke himself has been described as "a force of nature". Obeying the impulses of vigorous instinct, he pours over us the full flood of his sensations and feelings, indiscriminately. Here, side by side, are brutality and delicacy, crudeness and subtlety. It may sometimes happen that no deep inner compulsion underlies the picture; and in that case its distortions seem forced, its clumsiness obtrusive rather than significant. But the art revealed in Permeke's best works has great power and a richly individual flavour. The restricted character of his palette does not detract from the vibrant lyricism of his colour.

PICASSO Pablo (Malaga 1881 - Mougins, France, 1973). Expressionist tendencies are by no means always predominant in Picasso's work, but they are liable to play an important part in it. They are noticeable throughout his Blue period (1901-1904), in Barcelona and later in Paris. Undoubtedly, in these figures of mothers bending tenderly over their pale fragile infants, in these old beggars whose emaciation is so painfully emphasized, in all these sickly creatures with their sorrowful faces, long thin fingers, anaemic and bony bodies, we can recognize a timid sort of Expressionism which is not free from mannerism and sentimentality. But a few years later (1907-1908) the lines have discarded their flowing movement; the forms are hardened and ruthlessly simplified; something harsh and sombre is revealed in the faces, and the bodies lose their grace. As these figures directly herald those of the Cubist period, we may wonder, indeed, whether their expressiveness is not simply the result of aesthetic experiment. Yet that expressiveness is undeniable; the laconicism of Picasso's style gives it an immediately striking strength.

Although in his Cubist period Picasso naturally turned away from Expressionism, he never definitely abandoned it. He was

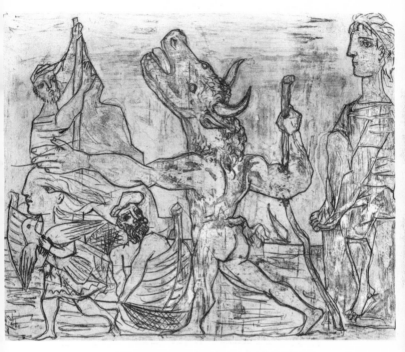

PICASSO. THE BLIND MINOTAUR. 1934. MIXED MEDIA

later to return to it, giving it perhaps the most shattering form ever put at its disposal by the very fact that it turned to account the experiments of Cubism. Already in the *Three Dancers* of 1925 he had reinvented bodies so as to represent in an exaggerated form the movements of a frenzied dance. It would be untrue to say that all the figures of the following years can be considered as Expressionist too, since some of them are too obviously the work of a man who, in the search for new forms and new combinations of forms, is ready to bring into play even the caprices of his fantasy. But a painting like the *Bather beside the sea* (1930) is not merely a composition of volumes created with a total disregard for anatomy; these pincers with serrated edges that represent a mouth and chin show that a

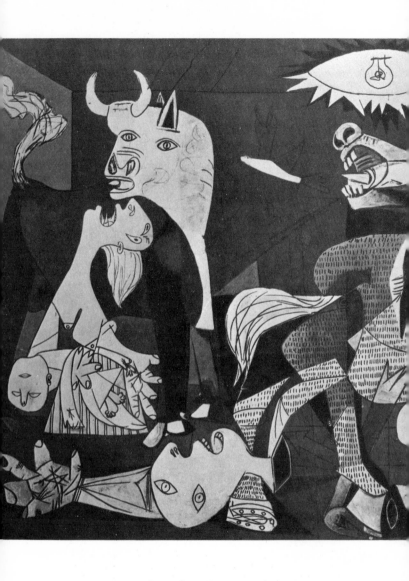

PICASSO. GUERNICA. 1937. (DETAIL). ON LOAN, MUSEUM OF MODERN ART, NEW YORK

PICASSO.
WEEPING WOMAN. 1937.
ROLAND PENROSE
COLLECTION,
LONDON

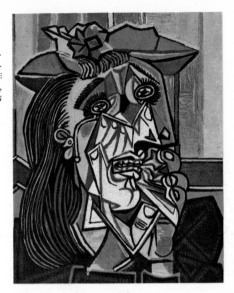

PICASSO. WOMAN WITH DOG. 1953. S. ROSENGART COLLECTION, LUCERNE

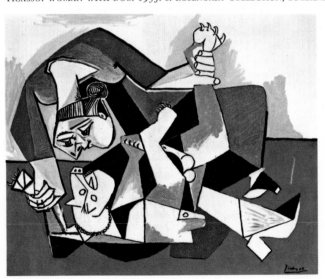

certain conception of woman is being expressed: a highly unflattering conception, to say the least. Picasso was to paint other canvases in which woman assumes a grotesque or pitiable aspect. And this is sometimes in order to express some feeling of irritation or hatred towards her, sometimes to convey a sense of her suffering under misfortune or inhuman treatment. Picasso's Expressionism was reawakened by the Spanish civil war and by the second world war. Thus in the great composition that he created to denounce the bombardment of Guernica (1937) he distorts bodies and faces with the utmost freedom, in order to convey directly the terror, distress, stupefaction and fury aroused by this sudden devastation, inflicted indiscriminately upon fighters and children, animals and human beings. The cruelty of the disaster is expressed not only by the figures themselves but also by lines and colours: the clear, incisive, implacable brush strokes, the stiff or broken verticals, the curves that seem to be drawn out, as though breathless, in precipitate flight, and the grave, mournful colour, where light greys are always surrounded by dark greys or strongly contrasting blacks. But Picasso can be equally expressionistic when he uses bright colours. This is shown in the *Weeping Woman* (1937), another work inspired by the Spanish war, where reds, greens, yellows and blues emphasize the harsh angularity of the drawing.

Between 1939 and 1945, Picasso produced a whole series of faces twisted, disfigured and recomposed so as to express dejection or consternation, fear or resentment. Their gaze seems all the more distraught because the eyes are often not in the proper place, and the bodies are just as distorted as the faces. Although these paintings have titles like *Woman in a Green Suit* (1940) or *Woman in a Blue Blouse* (1941), *Reclining Nude* (1942) or *Woman with a bunch of flowers* (1942), we must unquestionably see in them the reflection of the brutal actions and the sufferings of humanity during the last war. The cruelty of real life at that time also finds expression in such a work as *Cat and Bird* (1939), where the figure of the cat is essentially that of a bloodthirsty creature whereas the bird, from beak to tail, represents the tortured victim. This intensely expressionist period ended with the war, but in some of Picasso's later work, particularly in the variations on David's *Rape of the Sabines* (1962-1963), we

recognize the same impulse. Basically, the tendency towards Expressionism was part of his nature and, although it was at times eclipsed, it was always liable to re-emerge.

PIGNON Édouard (b. 1905 at Bully, Pas-de-Calais). Pignon, who had been a manual worker, learnt his art by attending evening classes in Paris and by visiting exhibitions. Between 1939 and 1945, following the lead of Lhote and Matisse, he painted figures and still lifes which are far removed from the work of the Expressionists. And if he shows a certain kinship with the latter in his *Old Catalan Women* (1946), painted under the influence of Picasso, he parts company with them again in the solidly constructed works produced during a stay in Ostend (1947-1949). On the other hand the *Fighting Cocks, Battles* and *Warriors* which he has painted since 1958 unquestionably display certain features which justify the term Expressionist. Impetuous lines, slashed contours, rigid or convulsive forms, wild movements that soar triumphantly or collapse shattered, cruelly strident colours contrasting with jagged, tragic blacks— with such means, in his *Fighting Cocks* (1958-1961) he depicts the internecine conflict not merely between two birds but between two hostile powers with terrible resources. One inevitably thinks of those relentless struggles which, ever since the last war, men have been waging against one another in Africa and America as well as in Asia. At all events, these struggles have undoubtedly had a profound emotional effect on Pignon, and he seems obsessed by them. In his *Battles* (1963-1965) we can make out spears and armour, but what we chiefly notice is the onslaught of sharp-edged forms, a furious and tenacious impetuosity, a tumultuous conflict, a clash of colours. For that matter, Pignon's painting is scarcely less dramatic when his subject is *Threshing*. In the *War Harvest* which he painted in 1962 the forms are perhaps less harsh than those of his *Battles*, but the effect of the whole reveals that he cannot help thinking of a battle as soon as his theme implies the play of forces and efforts; while in his *Warriors' Heads* (1967-1970), the heads are entirely recomposed so as to express primarily relentlessness and anguish. In many cases the mouth becomes something between a bull's muzzle and the jaws of a wild animal; the eyes glaze with rage or terror; the lines are broad and twisted, the colours

often obsessive. Like Picasso, Pignon shows that it is possible to reject the norms of realism and yet convey a profound and striking truth.

POLLOCK Jackson (Cody, Wyoming, 1912 – East Hampton, 1956). He studied first in Los Angeles in 1925 and then, from 1929 onwards, in New York. His expressionist tendencies showed themselves early; thus a *Seascape* of 1934 is curiously reminiscent of Nolde, although it was more probably inspired by Tintoretto, whom Pollock studied closely at that time. A few years later, some of his drawings seem directly suggested by the work of Picasso, notably by *Guernica* or by the paintings and engravings made around 1936. But Pollock was at the same time interested in the art of the American Indians and in that of the Mexican Expressionists Orozco and Siqueiros. Here and there he also reveals his admiration for Miró. Moreover, during the last war he was in direct contact with the Surrealists in New York, more particularly with Matta. All this led him to create an art in which a certain degree of representation is lost in a medley of violent lines and colours. Occasionally one can make out a human or animal figure that seems to have sprung from a subconscious haunted by anxiety and eroticism. Certain works of 1943 or 1946 thus anticipate the COBRA group, which was not formed until some years later. It was in 1946 that Pollock began to produce large paintings by means of a technique known as *dripping*, which had already been occasionally used by Masson and Max Ernst: instead of using an easel and brushes, he laid the canvas flat on the ground and splashed the paint on to it by swinging pierced tins. By this means he hoped to express his subconscious impulses in the most direct way possible. In fact, the very violence of his gestures did not always retain its expressive power, because the lines end by forming so inextricable a tangle that the eye fails to follow their path and to be conscious of the motive behind them. Thus the final effect of this automatic method of painting is principally decorative; particularly since the colour, with its shades of orange and mauve, its silvery blots and networks, has a certain prettiness. Towards 1951 Pollock gave up colour in favour of black and white. He therefore also had to give up covering the entire surface of his picture, so that the composition becomes

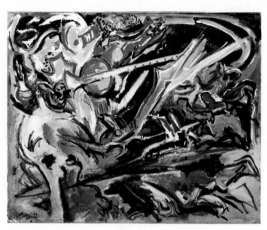

PIGNON.
BATTLE. 1963.
GALERIE DE
FRANCE, PARIS

POLLOCK. PAINTING NO. 12. 1952.
NELSON A. ROCKEFELLER COLLECTION, NEW YORK

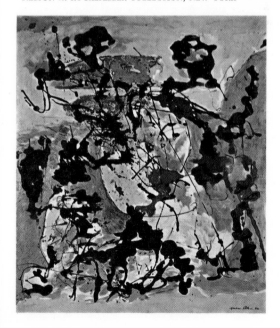

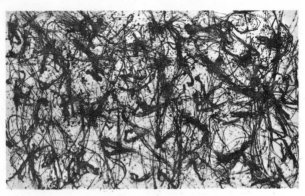

POLLOCK. NO. 32. 1950.
KUNSTSAMMLUNG NORDRHEIN-WESTFALEN, DÜSSELDORF

more clearly articulated. At the same time figures, which for a while had been completely absent, reappear, and they have an unmistakably expressionist character. Pollock was to revert to the use of colour, but his final tendency was to introduce actual shapes rather than the confused tangle of lines characteristic of his work between 1946 and 1951.

REBEYROLLE Paul (b. 1926 at Eymoutiers, Haute-Vienne). When he came to Paris in 1944 he acquired his artistic training by working at La Grande Chaumière and by frequenting other artists or studying their work. He was influenced by Picasso, Soutine and Van Gogh, and for a while was guided by Lorjou. Thus, towards 1948, he practised an expressionist realism which reminds one of the latter artist. But for the past ten years or so his style has become so free that many of his paintings might be taken for abstract works. Not all of them are related to Expressionism. Those produced in 1955-1956 can even be described as pure painting, although the means employed are not exclusively traditional. Moreover the impulsive handling in his landscapes of 1964 bears witness to petulant vitality rather than to a tormented spirit. None the less he produced a large number of paintings wich entitle him to a place in this book. Thus when he paints nudes or couples on a bed

(1961-1963) he gives them an unrecognizable and ridiculous aspect: they suggest plucked chickens rather than human beings, and where one might expect to see arms and legs one finds insects' feet or crabs' claws. If these paintings are nevertheless not hideous, it is because the rosy tints of the bodies glow splendidly against his whites and greys. Rebeyrolle's expressionism is equally evident in his series of *Guerrilleros* (1967-1968). Whether the theme of his composition is *The Blood of Che* (Guevara) or a dead bird, he confronts us with a harsh reality where pitfalls abound, and we feel that at any moment the dark brown of the gritty soil may be stained red by blood flowing from wounds.

ROHLFS Christian (Niendorf, Holstein, 1849 - Hagen, 1938). Although born before the three pioneers of modern Expressionism, Van Gogh, Ensor and Munch, Rohlfs did not show any of the tendencies which they represent until 1910, when he was over sixty. In Weimar, where he entered the Academy in 1870 and where he lived until the early years of this century, he was at first attracted by naturalism, then, towards 1897, he worked in an Impressionist manner. In 1910 he was appointed to a teaching post at the Folkwang School at Hagen, and thenceforward lived chiefly in this town, whose famous Folkwang Museum acquired, after 1902, works by Gauguin, Van Gogh, Cézanne, Matisse, Munch, etc. During the summers of 1905 and 1906 he painted in the medieval town of Soest in Westphalia, which was still to inspire him a dozen years later. Here he met Nolde, who was also about to go beyond Impressionism; but the two artists were quite unlike in temperament. There was nothing vehement about Rohlfs, and while he sometimes used bright colours, he preferred to contrast them with muted tones. Moreover he was not indifferent to form. In the works painted in 1919 or thereabouts the figures, as well as the buildings, are suggested by long geometrical lines, and the picture is structured in a way that somewhat recalls Cubism and Futurism. Yet Rohlfs showed an increasing tendency to blur his outlines and veil his forms. He found an appropriate medium in watercolour, in which imprecision is not only acceptable but can produce admirable effects. Towards the end of his life, particularly in Ascona where he spent part of each

ROUAULT.
TWO NUDES. ABOUT 1905.
OIL ON PAPER.
METROPOLITAN MUSEUM
OF ART, NEW YORK

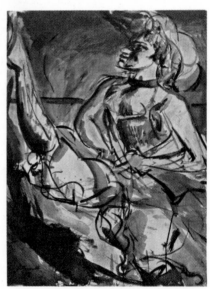

ROUAULT.
AT TABARIN'S,
OR THE CHAHUT.
1905.
PRIVATE COLLECTION,
PARIS

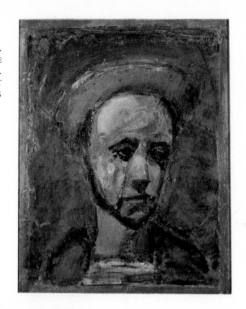

ROUAULT.
THE APPRENTICE
(SELF-PORTRAIT). 1925.
MUSÉE NATIONAL D'ART
MODERNE, PARIS

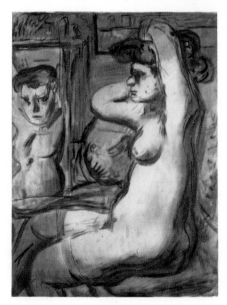

ROUAULT.
AT THE MIRROR.
1906.
MUSÉE NATIONAL
D'ART MODERNE,
PARIS

year from 1926 onwards, he uses dark browns and muted yellows and blues in painting flower-pieces and landscapes which, though elusive and somewhat indistinct, have considerable charm.

ROUAULT Georges (Paris, 1871 - Paris, 1957). At fourteen years old he was apprenticed to a stained-glass artist, from whom he learnt to restore medieval windows; he was never to forget what this experience taught him. At the École des Beaux-Arts in Paris, which he entered towards the end of 1890, he became a pupil of the Symbolist Gustave Moreau in 1892. Inspired furthermore by Leonardo, Rembrandt and Goya, he was immediately drawn to the kind of painting which is not restricted to outward appearances. True, when towards the end of the last century he treated religious themes, he remained faithful to tradition and followed in his master's footsteps. But in 1903 he turned to fresh subjects: for a number of years he painted chiefly prostitutes and clowns. He painted them in the spirit of a Christian, horrified by the sight of sin and distressed by that of poverty. His nonconformism and the passionate character of his protest were strengthened by his friendship with Léon Bloy, whose *Désespéré* and *Femme pauvre* touched him deeply. His art became a violent act of accusation. Instead of contemplating prostitutes with the curiosity of Toulouse-Lautrec, who delighted in observing their everyday life, Rouault could see in them only the embodiment of an irremediable and terrifying fall from grace. Their bodies are ungainly, shapeless, often swollen to the point of monstrous deformity, and the faces are squalid, their stupidity as repulsive as their ugliness. On the other hand his clowns are depicted with sympathy, almost with tenderness. And yet he does not seek to idealise them. Their faces show the marks of blows, injuries and humiliations; their cheeks are hollow or bloated.

Another type of subject obsessed the painter, towards 1910: *Judges*. He shows these as ferocious and sinister, alternately robed in a false dignity and hopelessly at a loss when confronted with the complexity of a human situation on which they must pass judgment. Daumier, indeed, had shown no kindness towards the *Gens de Justice*, but his work appears positively indulgent when compared to that of Rouault. Not that the

latter artist had sought solely to express his pity or his indigna-
tion. "A black cap and a red robe make fine patches of colour",
he said. In the same way, when, towards 1904, his drawing
seems to be the result of exacerbated fury, we must not explain
this impetuous style as simply the mark of a lover of justice,
excitedly expressing his anger. The most violent of his works
are, in fact, those which inaugurate his new orientation: their
vehemence can be further accounted for by a wish to be free
from habits acquired as a student. Already by 1905 his art has
become not less intense but less excitable and shrill. The lines
are clearer, the form is more tangible, the colour less blotchy,
less scarred, purer and richer. The dominant colour is now
blue—a blue verging on green or on violet—now a faded rose-
colour, but invariably the colour-scheme is notable for its rare
and subtle quality. From his earliest days Rouault had loved
chiaroscuro, and for years the opposition between light and
dark remained one of his essential resources. Watercolour,
which he chiefly practised at this period, with the occasional
addition of pastel and gouache, gave lightness and an effect of
transparency to his colour and enhanced its attractiveness.
Towards 1910 his whiplash line is replaced by a broad emphatic
stroke, his colour becomes stronger and, in his oil paintings,
the impasto becomes heavier.

From 1917 to 1927, Rouault devoted himself chiefly to
engraving. Using a highly complex technique, which enabled
him to achieve painterly effects, he produced, in particular, the
sixty or so plates which make up the *Miserere*. Some of them
have religious subjects connected with the Passion. Not sur-
prisingly, these are among the finest achievements in the book;
throughout his career Rouault showed himself a religious
painter as authentic as those of the Middle Ages. Not only was
he a whole-hearted believer, a man of fundamentally religious
nature, but also a fervent visionary. This quality is equally
apparent in his landscapes, particularly in the many Gospel
scenes which he painted after 1930. From the topographical
point of view, these landscapes are not suggestive of Palestine;
they reveal no local colour, no hint of Eastern "picturesque-
ness". The buildings are invented, and so is the lie of the land.
Yet one cannot question the religious atmosphere that pervades
these paintings. Furthermore, the same characteristics are shown

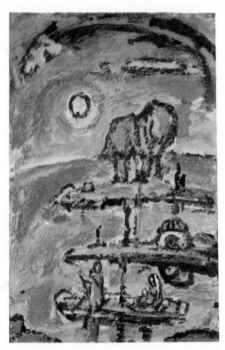

ROUAULT.
CHRISTIAN NOCTURNE. 1952.
MUSÉE NATIONAL
D'ART MODERNE,
PARIS

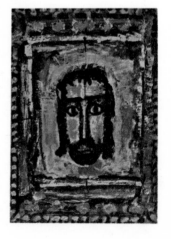

ROUAULT.
THE HOLY FACE. 1933.
MUSÉE NATIONAL
D'ART MODERNE,
PARIS

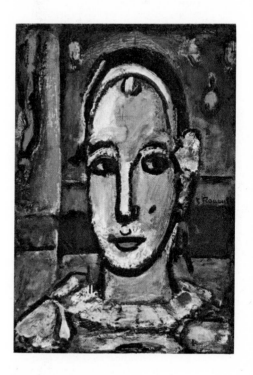

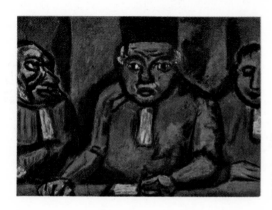

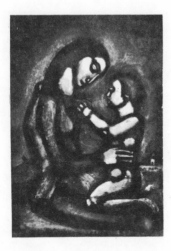

ROUAULT.
BELLA MATRIBUS DETESTATA.
ETCHING FROM
"MISERERE"
(PUBLISHED 1948)

in works entitled *Late Autumn* or *Twilight*, which goes to show that everything created by this artist arises from a single source and is entirely in keeping with his most authentic inner feelings. When, from 1930 onwards, Rouault paints figures other than that of the suffering Christ, he tends to give them calmer expressions. Instead of fighting against vice and injustice, he now prefers to contrast with these a world of his own creation which denies or ignores them. Thus his degraded prostitutes are supplanted by women who have the spiritual nobility and the discreet grandeur of certain legendary heroines. Rouault's style changed at the same time as the atmosphere of his works. His forms become more regular, the chiaroscuro effects are replaced by colour contrasts that glow with subdued warmth. Moreover, seeking to increase the thickness of his impasto, the artist may spend months, even years, applying successive layers of paint. Yet his texture never looks heavy or opaque; it appears sublimated and ennobled, steeped in light and pervaded by a spiritual quality.

SAURA Antonio (b. 1930 at Huesca, Spain). Of mingled Jewish and Arab origin, Saura turned to painting during an illness which kept him bedridden for several years (1943-1947).

To begin with he was attracted by the Surrealists, and when in 1953 he settled in Paris he made contact with them. However, he parted company with them shortly afterwards, being inclined by temperament not towards a "photographic" method but towards gestural or action painting, towards a direct form of expression to which, furthermore, he was impelled by the examples of Picasso and Goya. In 1955 he returned to Spain, and here the dramatically tortured character of his art became more marked. Whether his theme is a crowd or a single figure, a nude or a Crucifixion, he paints with vehemence, entangling his strokes and presenting us with convulsed and mutilated forms, which seem lacerated with the marks of the lash or with stab-wounds. The faces to be discerned amidst the tangle of lines are haggard, conveying the impression that excess of misfortune and suffering have brought them to the verge of insensibility. His colour, in which black and white predominate, enhances the pathos of this tense, anguished art, which seems fiercely dedicated to interpreting in a ruthless fashion the sense of being in an inhuman world.

SCHIELE Egon (Tulln, near Vienna, 1890 - Vienna, 1918). In 1906 he entered the Vienna Academy of Art. A year later he met Klimt, under whose influence he became an adherent of the *Jugendstil*. However, before long he abandoned the flowing curves of this school in favour of a hard line which seems constantly to come up against some obstacle, stopping abruptly, breaking off, diverging, so that his flattened forms seem to have been cut out with a knife. As for his colour, it is sometimes gaudy, but generally has a melancholy tinge. Although Schiele painted landscapes and town views, his chief interest was the human figure. His models wear fixed stares, while their gnarled hands are either convulsive or paralytic. Even his embracing lovers express disillusionment rather than delight. Schiele's art, in short, is both morbid and mannered, cruelly expressive of nervous tension.

SCHMIDT-ROTTLUFF Karl (born 1884 at Rottluff near Chemnitz). Like Heckel and Kirchner, his friends and co-founders, in 1905, of *Die Brücke* at Dresden, Schmidt-Rottluff used an impressionist's palette to paint in the manner of Van

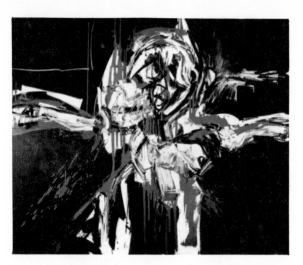

SAURA. CRUCIFIXION. 1963. PRIVATE COLLECTION

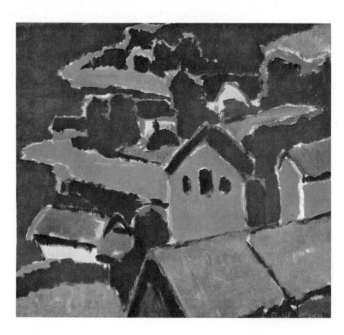

SCHMIDT-ROTTLUFF. REST IN THE STUDIO. 1910. KUNSTHALLE, HAMBURG

SCHMIDT-ROTTLUFF. LOFTHUS. 1911.
KUNSTHALLE, HAMBURG.

Gogh, but with greater vehemence and harshness. He painted portraits and, above all, landscapes, several of these being inspired by the country round Dangast (Oldenburg), where he stayed on several occasions between 1907 and 1914. But in 1911 he also produced pictures on Norwegian themes; the colour here is as bright and more sustained than in his other canvases, while the draughtmanship is firmer and the structure of the work is vigorously emphasized. Schmidt-Rottluff came to stress form even more strongly after he settled in Berlin at the end of 1911. He produced landscapes, nudes, portraits in an interior or outdoor setting, where the volumes are summarily geometricized and the linear structure of the composition is brought out. At the same time his figures assume rigid gestures and expressions that are serious to the point of sullenness. The influence of Negro sculpture can undoubtedly be recognized here, but one feels that the artist has accepted this influence deliberately because it helps to endow his work with that laconic gravity for which he seeks. The human beings he depicts are almost exclusively young women obsessed with unhappy thoughts, weighed down by some mysterious curse. Their eyes are generally cast down, their prominent lips seem to utter only moans and sighs, their arms, their hands, their attitudes express nothing but helplessness and inconsolable distress. Moreover, these creatures who seem doomed to endless longing for a lost Paradise resemble statues rather than real people. The landscapes in which they are set also have an unreal air, as though they belonged not to Germany but to some strange exotic region. In every respect, therefore, we feel in an unfamiliar world, the more so in that the colour makes no attempt at verisimilitude: red or mauve tree-trunks are as common in these paintings as green or blue faces. Another characteristic of Schmidt-Rottluff's work is that his nudes, unlike those of Kirchner (and sometimes of Heckel) have no suggestion of eroticism. There are no men beside these un-clothed women, not even the idea that a man might be with them. Only rarely does he represent couples, in certain portraits for instance, and then no particular tension seems to be involved.

Towards 1923 Schmidt-Rottluff begins to replace angles by emphatic curves; in general his line becomes heavier and brings out the roundness of his volumes more fully. He now moves

SCHMIDT-ROTTLUFF.
SEATED WOMAN.
1913. ETCHING

closer to Realism, although his art never became as tradition-
alist as Heckel's. A psychological change can also be noted:
although his figures retain their gravity they no longer seem
dejected. During the thirties Schmidt-Rottluff produced
some landscapes which show less inventiveness but a greater
breadth than those of 1913 or 1920. Here, objects are reduced
to masses which are almost monumental in their uprightness,
and the framework of the picture is strongly underlined.
German Expressionism can show few works as vigorously
constructed as these. Since the last war, the artist's colour has
become freer and brighter again, though not at the expense
of form; and while he once again flattens his shapes so that the
colour may retain its purity, he continues to structure his
picture with the aid of a broad, heavy stroke.

SIRONI. LANDSCAPE. PRIVATE COLLECTION

DE SMET.
THE BOX. 1928.
KUNSTMUSEUM,
BASEL

DE SMET. LARGE LANDSCAPE WITH COWS. 1928.
PRIVATE COLLECTION, BRUSSELS

SERVAES Albert (Ghent, 1883 - Lucerne, 1966). In 1905 this artist joined Van den Berghe and Van de Woestijne at Laethem-Saint-Martin, having met them while following evening classes at the Art Academy of Ghent (1900-1904). He first came under the influence of the Symbolists Van de Woestijne and Minne, but the example of Jakob Smits set him on the path leading to Expressionism. By means of dark or muted colours he painted scenes of peasant life, but his limp and schematic forms indicate a somewhat sentimental approach, lacking in creative force. In 1919 he produced a series of charcoal drawings of the Stations of the Cross which, after giving rise to impassioned controversies, was banned by the Vatican from being shown in any church. What seemed so shocking about the work was that it portrays Christ as a pitiable creature, with painfully emaciated body, long scraggy neck and tangled hair and beard, while those who surround him are almost equally cadaverous. This set of drawings, engendered by an ecstatic fervour, are Servaes' most remarkable achievement. None the less, even here his line is limp and mannered; there is more originality of vision than firmness and sharpness of style. Although he went on painting landscapes and country scenes, Servaes was henceforward to concentrate chiefly on religious subjects: for example a second and third series of Stations of the Cross, this time in oils, the later of these being destined for the Abbey of Orval, and a series of paintings on the Life of the Virgin. Towards the end of the last war, during which his Expressionist tendencies did not prevent him from displaying his Nazi sympathies, he left Laethem as a fugitive from Belgian justice, and settled in Lucerne. Here he continued to produce impetuous paintings on religious themes, together with mountain landscapes.

SIRONI Mario (Sassari, Sardinia, 1885 - Milan, 1961). His studies brought him to Rome, where he came into contact with the originators of the Futurist movement: Balla, Boccioni and Severini. He also took an interest in Cubism. In 1914 he settled in Milan, and from 1920 onwards he began to paint in a manner which is at once expressionistic and archaistic. His figures, as stiff as archaic statues, are usually clad in greys and browns, and their settings are some sort of underground

galleries or cellars, dimly lit. Sironi also painted urban land-scapes in which rows of cubic houses with monotonous façades, pierced with blind windows, produce an oppressive atmosphere. Even in the open air his light lacks warmth or gaiety. But as with any true artist, the drabness of his subjects is counter-balanced by the painterly qualities of his treatment, particularly by the distinction of his colour, which is muted and yet vibrant.

SLUYTERS Jan (Bois-le-Duc, 1881 – Amsterdam, 1957). There were various periods in this painter's career, and the most definitely expressionistic period was neither the longest nor the most fruitful. Yet the art historian cannot neglect it, for it had an effect upon the course of Flemish Expressionism. It occurred around 1915-1916, at the time when Gustave de Smet and Van den Berghe were staying in the Netherlands. Sluyters, who had been attracted to Cubism in 1913 and who was now under the influence of Le Fauconnier, was working in the village of Staphorst, where the peasants were strict Cal-vinists; and for a few months he sought to convey the rigour and austerity governing the lives of these Puritans by means of dark colours and forms that were stiff as well as simplified. However, his basically sensuous nature, his love of life, which had found expression in 1906 when, in Paris, he had been drawn to Cubism, led him to resume a bright palette and a more flexible line; and if certain of his later paintings still suggest Expressionism, for the most part they are the unrestrained manifestation of a temperament inclined neither to asceticism nor to melancholy.

SMET Gustave de (Ghent, 1877 – Deurle, 1943). When he came to live in Laethem-Saint-Martin in 1908, some twelve years after completing his studies at the Academy of Ghent, Gustave de Smet was an exponent of the luminism of the Impressionists. When the 1914 war broke out he took refuge in Holland, where the sense of exile, the discovery of the art of Franz Marc and Campendonk, and above all his relations with Le Fauconnier, with Sluyters and other Dutch Expression-ists, produced a radical transformation of his style. In 1917 he painted a *Spakenburg Fisherman's wife* which recalls the women of Zeeland portrayed by Le Fauconnier and Sluyters' Staphorst

SOLANA. CHORUS GIRLS. ABOUT 1922. MUSEUM OF MODERN ART, BARCELONA

SOUTINE. LANDSCAPE. 1926. PRIVATE COLLECTION, LONDON

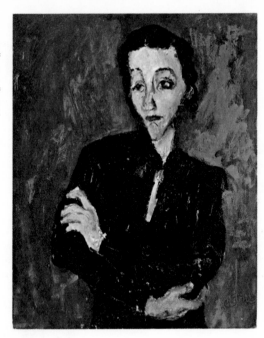

SOUTINE.
PORTRAIT OF
MARIA LANI.
ABOUT 1929.
MUSEUM OF
MODERN ART,
NEW YORK

SOUTINE.
WOMAN IN RED.
HARRY BAKWIN
COLLECTION,
NEW YORK

peasants. The works he produced until about 1921 reflect unease. The houses of Amsterdam appear to lean on one another as if they could only stand upright by propping each other up. The sky is furrowed with great intersecting and conflicting curves. Loving couples walking down a street are assailed by diagonals that clash like hostile forces. Their faces express uncertainty and sadness. The morose element apparent in his Dutch period begins to disappear in 1922, when Gustave de Smet went back to settle in Belgium. His figures retain their gravity, and at the start of this period their faces and attitudes still betray unease of mind, but before long we trace in their expressions merely an impassive thoughtfulness. De Smet took most of his subjects from the countryside around Ghent, where he lived first at Afsne, then at Deurle: a husband and wife drinking coffee, an engaged couple in a room with their parents, a young woman deep in nostalgic reverie, men at a tavern, family parties eating mussels in a restaurant, or on a boating expedition, and the occasional huntsman, poacher or fisherman. If some of these themes recall those of Permeke, the atmosphere is quite different. There are seldom any emotional tensions between the characters depicted here; but neither is there any expansive communication. They live side by side, they sometimes glance at one another and exchange a few guarded words, but they never confide. Even his married couples live their separate lives, not through mutual hostility but because they each have their own private life, their personal inclinations and aspirations, which are suggested though never defined by their fixed gaze.

The landscapes painted by Gustave de Smet after his return to Flanders show small, simple houses neatly grouped around the church, with a few bushy trees here and there; cows peacefully grazing near the farm have the touching look of toy animals. The whole thing, for that matter, has something of a toylike air; the artist's style has pruned away the harshness of reality, though not its truth. The slanting lines of his Dutch period are now replaced by uprights and horizontals, the curves flow more gradually, the volumes, still constructed with regularity, have become less stiff; lights and shadows contrast without clashing. There is no clash, either, in the colour, which includes many browns (maroon, blackish and

reddish browns), besides ochre, brick red, rose-colour, lilac, pale violet, dull blues and greens, the whole effect being muted and yet pervaded by a gentle warmth. Apart from the themes provided by village life, Gustave de Smet treated a few, between 1926 and 1928, which were suggested by city scenes: a band playing the blues, a circus equestrienne, a couple in a theatre box. Whereas formerly he had given his pictures a structure which was expressive as well as solid, he now sometimes composes them too carefully, in too systematic a fashion, so that he is liable to lapse into frigid decorative stylization. However, towards 1930 he not only gave up schematizing his forms but even allowed them something of that irregularity which belongs to natural objects. In 1937 he categorically rejected the rigour which he had cultivated for so long, and eventually took to drawing in a more or less realistic fashion.

SOLANA José Gutierrez (Madrid, 1886 – Madrid, 1945). He was self-taught, and had little contact with modern art; generally speaking, he is more akin to Goya than to the masters of contemporary painting. His colour is harsh and austere, including much black, ochre and grey, and his drawing is in fact realistic, yet to stress his intentions Solana simplifies and emphasizes. He liked to haunt the more squalid districts of Madrid and to depict figures like those he met there. Moreover his interest in waxworks, and a visit to the Musée Grévin, led him to compose imaginary scenes from the French Revolution. He often painted groups: chorus girls dressing, friends meeting at a café, a procession of masked figures in a landscape, or the performers and spectators at a bull fight. When his figures are not wearing masks, their expressions are grave and anxious, and they seem to have come together not to communicate with one another but to display before the world the heart-rending loneliness in which each of them is confined.

SOUTINE Chaim (Smilovichi near Minsk, Lithuania, 1893 – Paris, 1943). As the tenth child in a poor Jewish family, Soutine was early acquainted with poverty and fear, humiliation and frustration. Even his artistic vocation earned him rebuffs and blows, and he had to run away from home in order to study first at Minsk, then at the School of Fine Arts at

SOUTINE.
LANDSCAPE. 1939.
M^{me} CASTAING
COLLECTION,
LÈVES

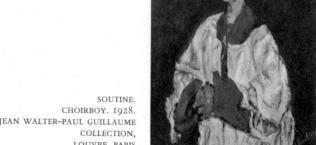

SOUTINE.
CHOIRBOY. 1928.
JEAN WALTER–PAUL GUILLAUME
COLLECTION,
LOUVRE, PARIS

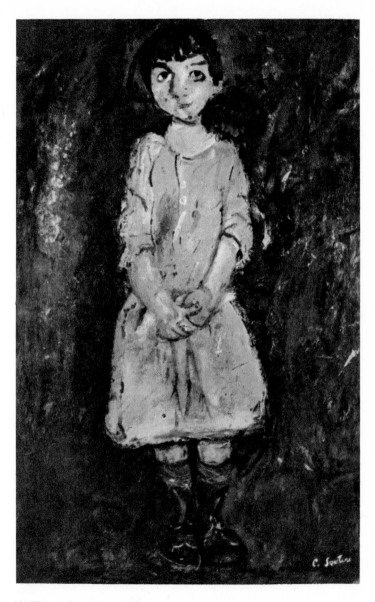

SOUTINE. LITTLE GIRL IN PINK. PRIVATE COLLECTION, PARIS

Vilna (1910). In 1913 he came to Paris. Here he studied for a while at the École des Beaux-Arts, but, more important, since he lived in Montparnasse he came into contact with such artists as Chagall, and became a close friend of Lipchitz and Modigliani. Yet he was still dogged by poverty, and in fact was never free of it, even when a few years later his works began to sell, since the memory of what he had endured haunted him so painfully that his art always remained that of a tormented being.

In the landscapes which he painted towards 1920 at Céret and Cagnes, the houses totter, as though about to collapse into heaps of dust and rubble under the impact of some irresistible cataclysm. Later, his *Trees at Vence* (1929), his *Chartres Cathedral* (1933), and the subjects he found in the region round Auxerre (1939) or Champigny (towards 1941) display a somewhat less convulsive draughtsmanship, but seldom does he show a house standing upright; the spires of Chartres Cathedral seem to reel in their fervent upsoaring; the trees are tangled and twisted by frantic winds, their thin trunks are bowed as if in pain, and their foliage waves and writhes tormentedly.

Soutine's distress is revealed in his figures and still lifes as much as in his landscapes. The *Women in Red* (1922) display the pitiful ugliness of those ageing beauties who seek to disguise their physical decrepitude by means of over-bright make-up. Their fashionable hats make them look cruelly ridiculous. Their fingers are gnarled and stiff. The withered body is suggested under the spreading red dress that fills the picture. In *The Pastry Cooks* (1922-1927) he depicts less pitiable creatures, yet they seem cowed and sickly. His *Grooms, Valets, Choirboys* (1925-1930), with their loose lips, their sly uneasy glances, wear the look of beings used to constant humiliation and dreaming only of an opportunity for surreptitious revenge. When he paints a woman with her child on her lap, the mother looks downcast and the child either stares fiercely, like a small potential sadist, or lies with its head against its mother's breast, lost in sleep as if in death, as stiff and shapeless as a puppet. Only a handful of portraits are to some extent the exception to this rule.

As for his still lifes, they deal chiefly with animals killed by man for food: herrings, plucked chickens or pheasants, flayed oxen. This latter theme is undoubtedly borrowed from Rem-

brandt; but Soutine treats it in his own manner: the forms are painfully distorted, the bloody aspect of the quartered animal is emphasized and its exposed flesh takes on a deeply disturbing tragic accent.

Are we to conclude from all this that Soutine's art is solely painful and depressing? That would mean forgetting that, as a painter, he never allows himself to yield to nihilism: he fights against its onslaught, he overcomes it, countering it with an art of such vivid quality that its final effect is far from depressing, but arouses excitement and delight.

Although primarily a colourist, he is concerned with beauty of texture as much as with harmony of hues. Not unexpectedly, Soutine had a great admiration for Rouault, Courbet and Rembrandt. His favourite colours are reds, whites, blues and greens, the latter being usually confined to his landscapes. And perhaps these preferences explain his choice and his repeated treatment of certain subjects. The pastry-cooks allowed him to modulate his shades of white, with his grooms he could indulge in glowing reds; while in his paintings of choirboys the two colours could be juxtaposed. Moreover, they differ from one painting to another: Soutine varies them untiringly, constantly introducing unexpected nuances. His whites, for instance, have an amazing richness. In general his colour, which is certainly not lacking in strong notes, includes a whole gamut of delicate tones. In his art, consequently, passion that is violent, though never vulgar, can coexist with delicacy, impetuousness with sensitive reticence, and while the image may be frightening, the painting is sheer delight.

SUTHERLAND Graham (b. 1903 in London). Not all Sutherland's work can be considered as expressionist. Yet some of his pictures, painted after 1935, which are full of long sharp thorns, of tangled prickly briars, of shapes that suggest buds swollen by unrestrained natural forces, entitle one to class him among the painters represented in this book. The same is true of his Crucifixions, particularly since some of the works in which thorns proliferate originated from a commission he received in 1945 to paint a *Crucifixion* for St. Matthew's Church, Northampton.

SUTHERLAND.
THORN HEAD.
1946.
PRIVATE
COLLECTION,
NEW YORK

SUTHERLAND.
ENTRANCE
TO A LANE. 1939.
TATE GALLERY,
LONDON

TYTGAT.
CIRCUS IN FLANDERS.
1925. MABILLE COLLECTION,
BRUSSELS

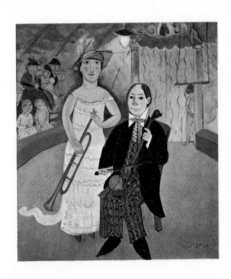

VAN VELDE.
COMPOSITION, 1955.
PRIVATE COLLECTION

TYTGAT Edgard (Brussels, 1879 - Brussels, 1957). Like almost all the representatives of Flemish Expressionism in the twenties, Tytgat was first attracted by Impressionism. It was only after the first world war that he asserted himself fully as the story-teller, the gently mischievous illustrator that his name suggests to us today. If many of his themes were taken from the real life that he saw around him at Nivelles, in Brussels and finally at Woluwé-Saint-Lambert, where he settled in 1924, others were purely imaginary. But, his portraits apart, the differences between the two types of picture are not considerable. Whether Tytgat is painting a cavalcade, a merry-go-round, an artist with his model or an Eastern fairy tale, he sees all his figures with the same ingenuous eye. And he generally gives them the look of figurines, thereby setting them apart in the world of legend. Even when he occasionally chooses pathetic subjects (*The Blind Man and Spring*, 1924; *The Sacrifice of Iphigenia*, 1929), he never depicts in a distressing form the painful situation or the drama suggested by the title. Tytgat's figures are remote from the brutality of real life not only in shape and size, but also through their colour, which is muted and full of tender feeling. Yet his painting is pervaded by a subtle nostalgia, by the gently persistent longing to regain a lost Paradise. We also find in it an appealing artlessness, a playful naïvety, in short a flavour of folk art, which does not preclude subtlety. Tytgat thus enriches Flemish Expressionism with characteristics which are certainly very different from those of Permeke or Van den Berghe, but which are none the less of value, and which we are not surprised to find in the country of Pieter Bruegel and of Uylenspiegel.

VEDOVA Emilio (b. 1919 in Venice). This self-taught artist began in 1936 by drawing imaginary architectural subjects, which already reveal baroque and expressionist tendencies. Towards 1946, disciplining his natural verve, he produced some abstract compositions consisting exclusively of strictly geometrical structures. None the less a certain impatience can be discerned in these pictures, which abound in clashes between oblique lines, acute angles and sharp points. Five years later, geometry is thrown to the winds: henceforward Vedova's paintings serve to express impetuously, indeed clamorously,

his turbulent emotions and his intellectual rebelliousness. Foamy whites are everywhere in conflict with jagged but tenacious blacks, and from their excited struggle there emerges a chiaroscuro expressive of anxiety, passion and torment. Colour is introduced here and there, but it plays no essential role; at times it seems to have been superadded. It figures more largely in the *plurimi*, those free groupings of panels which Vedova has been painting since 1960, although even here the clashes between violent colours are less expressive than the ruthless interplay between light and dark.

VELDE Bram van (b. 1895 at Zoeterwoude, near Leyden). He was originally apprenticed to a firm of painters and decorators at The Hague. From 1922 to 1924 he lived at Worpswede in North Germany, where he painted subjects from country life in a manner influenced by Expressionism. In 1925 he settled in Paris, where he mainly lived until 1965, since when his home has been in Geneva. Certain still lifes painted before 1930, in which the objects are less important than the streaks and patches of colour, anticipate the pattern of the non-figurative works on which his fame is based. These, which are all entitled *Painting* or *Gouache*, were not produced until after 1945, the war having interrupted his activity. Their lines are broad but lack firmness; they seem to crawl, and when they rise they do so half-heartedly and soon relapse in exhaustion. The resulting forms are limp, apparently tired and oppressed, as though seeking to demonstrate the futility of any effort. The colour conveys the same impression. It is undoubtedly original and uncommon; often light, fluid and transparent, it is capable of delicacy and distinction. But the deliberately unfinished look of Bram van Velde's handling makes it impossible to enjoy the qualities of his work without at the same time being aware of something that denies these or at any rate questions them. It is thus not surprising that this painter has won the special admiration of Samuel Beckett, who sees in him "the first to admit that to be an artist means to fail as nobody else dares to fail . . ."

VLAMINCK Maurice de (Paris, 1876 - Rueil-la-Gadelière, Eure-et-Loir, 1958). Vlaminck, who was self-taught, was one

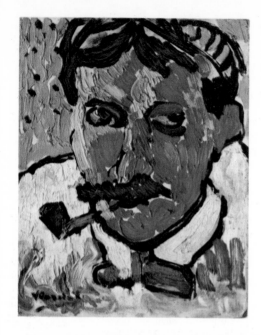

VLAMINCK.
PORTRAIT
OF ANDRÉ DERAIN.
1905.
PRIVATE COLLECTION,
PARIS

VLAMINCK. MARLY-LE-ROI, 1905

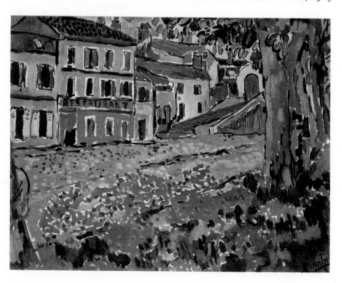

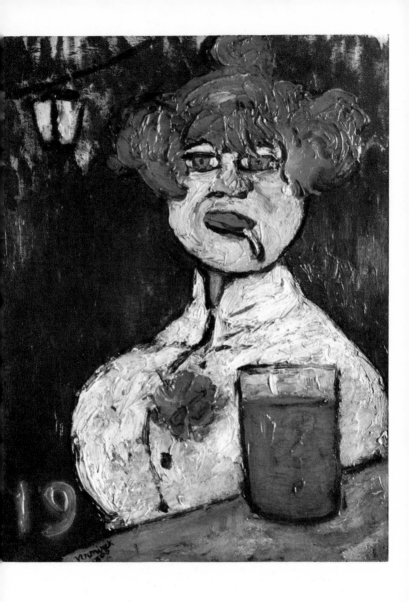

VLAMINCK. AT THE BAR. 1900. MUSÉE CALVET, AVIGNON

of the originators of Fauvism in 1905, and of all the artists who represented that tendency he was the most vehement, the least disciplined. "In 1900", he writes in *Désobéir* (1936), "on my release from military service, revolts were seething within me. Revolts against a society fettered by cramping conventions, restricted within a narrow framework, subjected to selfish and ungenerous laws. And the least shock, the least frustration would have been enough to make these revolts explode. . . . Painting served me as an outlet . . ." Such phrases show clearly that Vlaminck had diverged from the Fauvist movement as understood by Matisse and Derain, to take up his stand in the Expressionist camp. His paintings swarm with vermilion and pure yellow, with acid greens and intense blues, and since his lines are drawn with an impetus governed solely by the vagaries of a tumultuous and anarchic temperament, his landscapes, like his figures, convey passion, impatience and aggressiveness.

Although in 1908 Vlaminck set aside the colourful palette of Fauvism, and under the influence of Cézanne bridled his instinct, the conversion was, and could only be, a transitory one. After the 1914-1918 war his expressionist tendencies revived, and henceforward were to be exclusively characteristic of his art. He withdrew to the country, first to Valmondois in the Oise and then to Rueil-la-Gadelière; here, a fanatical indivi-dualist, hostile to the technological civilization that he saw displayed in cities, Vlaminck became the proponent not of a peaceful "back to the land" movement but of a return to what, in his view, was the essential truth of human life. And he never ceased to contrast this truth with the modern world which he detested and against which, when the opportunity arose, he would vituperate in his writings. For he could not ignore it. He did not seek to live a hermit's life, completely cut off from his contemporaries. He was one of the first to paint roads and landscapes as they are seen from a motor car. And when he does show the countryside as it appears to a traveller on foot, he never makes an idyll of it. He introduces a steaming locomo-tive beside a little station, reminding us of the existence of technology and of the ugly features it has introduced into nature; here a garage, elsewhere the chimneys of a factory. Even when Vlaminck simply paints a field of corn we never

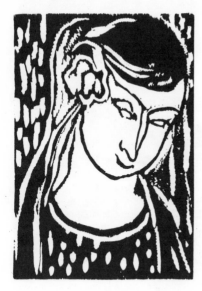

VLAMINCK.
WOMAN'S HEAD.
1906.
WOOD ENGRAVING

lose our awareness of living in the twentieth century. He shows no aspect of nature where peace has not been violated, or at any rate threatened. We most frequently have the feeling that some dramatic happening is lying in wait: it is in the air, in the light, in his colours. The yellow of his wind-tossed cornfield reminds one less of gold than of sulphur, with its suffocating smell. A drab inky grey darkens the heavy clouds that gather in his skies. The light seems about to be assaulted by a thunderstorm or extinguished by the sudden onset of night. Nothing could be more sinister, more depressing than this artist's winter scenes, where patches of dirty white surround joyless reds and gloomy browns. The countryside which is here contrasted with the town is unwelcoming; it will submit only to the man who tackles it with stubborn energy.

The flowers that Vlaminck paints have been picked in woods or fields, and even when arranged in bouquets they retain a sort of wildness. The subjects of his still lifes are usually such things as a loaf of coarse bread or a bottle of wine on a kitchen table, with some fruit, fish, or a piece of meat. In these paintings he expresses his interest in the simple things of everyday life;

VLAMINCK. VILLAGE WITH CORNFIELD. PRIVATE COLLECTION, PARIS

WOLS. PAINTING. JOHN LEFÈVRE COLLECTION, NEW YORK

but at the same time he shows his tendency to bring out the emotional contrast between light and dark passages. This tendency is noticeable in all the works painted after 1918. Towards the end of his life, however, his chiaroscuro is liable to assume a theatrical quality, his colours grow muddy and his hastily scribbled lines too often tell not of a genuine emotion but merely of an unsteady hand.

WOLS (Berlin, 1913 – Paris, 1951). Wolfgang Schulze, who adopted the pseudonym Wols, lived first in Dresden from the age of six, and began by displaying exceptional gifts for music and science. In 1931 he took up professional photography, and soon won recognition for the quality of his pictures. As moreover he had now begun to practise painting and drawing, he studied for some months at the Berlin Bauhaus, and then came to Paris where he tried to earn a living as photographer. From 1933 to 1935 he lived in Spain. After his return to Paris, he was interned on the outbreak of war and spent a year in prison camps. On his release he settled successively at Cassis and at Dieulefit (1942), only going back to Paris in 1945. Since leaving Germany he had often lived under difficult conditions, and always sought to evade the existence that the real world offered him. He had constant recourse to alcohol, which brought him an immediate escape but eventual self-destruction. His works undoubtedly recall those of Klee, but suggest a Klee grown neurotic and a prey to anguished obsessions. The slender lines which abound in his paintings are often twisted and tangled; sometimes they convey the notion of obsessive wanderings through a prison from which there is no way out, at other times we can make out ghostly faces amongst them, terrified eyes, amputated fingers, raw flesh, gaping wounds, animals' heads with disturbingly fixed stares. In other works, Wols constructs imaginary cities inhabited only by emptiness and nostalgia. Whereas in his watercolours the colour is generally not merely subdued but depressed, faded, anaemic, there is something more positive about the oil paintings which he produced during the last years of his life. Nevertheless it is in his drawings and watercolours that he expresses himself most strikingly, because here he could rely on automatism, and his art is above all an intimate confession. Whereas his works tend

mostly towards indirect representation, Wols also appears from time to time as one of the originators of abstract Expressionism and non-formal art.